annunciation

in the sixth month the angel gabriel was sent from god to a city of galilee named nazareth, to a virgin betrothed to a man whose name was joseph, of the house of david; and the virgin's name was mary. and he came to her and said, 'hail, o favoured one, the lord is with you!' but she was greatly troubled at the saying, and considered in her mind what sort of greeting this might be. and the angel said to her, 'do not be afraid, mary, for you have found favour with god. and behold, you will conceive in your womb and bear a son, and you shall call his name jesus. he will be great, and will be called the son of the most high; and the lord god will give to him the throne of his father david, and he will reign over the house of jacob for ever; and of his kingdom there will be no end.' and mary said to the angel, 'how shall this be, since i have no husband?' and the angel said to her, 'the holy spirit will come upon you, and the power of the most high will overshadow you; therefore the child to be born will be called holy, the son of god. and behold, your kinswoman elizabeth in her old age has also conceived a son; and this is the sixth month of her who was called barren. for with god nothing will be impossible.' and mary said, 'behold, i am the handmaid of the lord; let it be to me according to your word.' and the angel departed from her.

luke 1: 26–38

the motifs of the angel hovering above
mary and the descent of the holy spirit in
the form of a dove are not found in art
before this mosaic of the fifth century.

mosaic
432–40
santa maria maggiore, rome

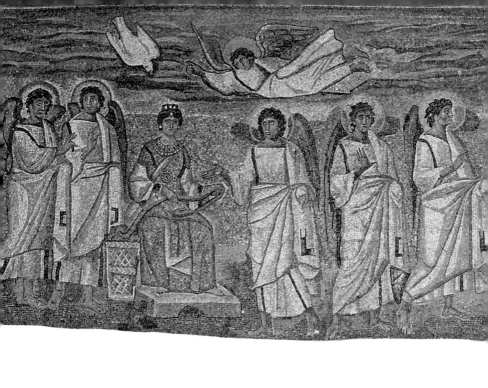

silk panel
c.700
biblioteca vaticana, rome

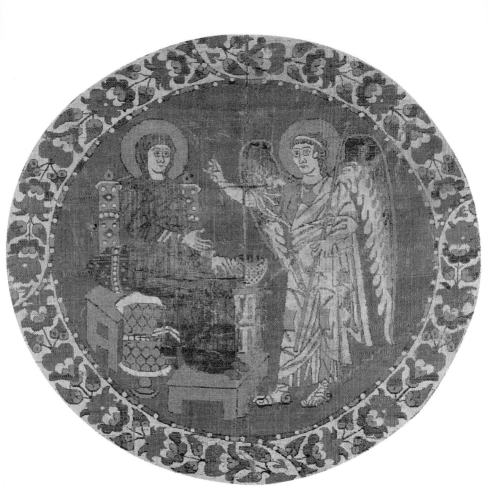

the wool basket at the virgin's feet
alludes to the legend of her upbringing in
the temple of jerusalem, where she span
and made robes for the priests. the story
serves to emphasize her purity and piety.

ivory relief
c.700
castello sforzesco, milan

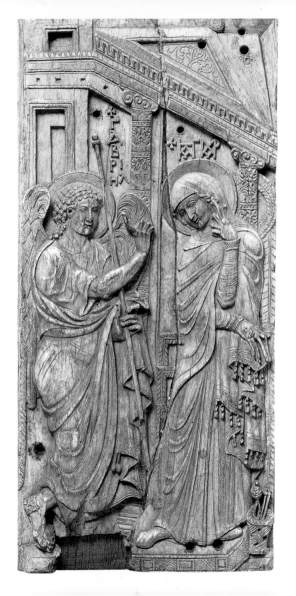

illuminated manuscript

c.983

staatsbibliothek, trier

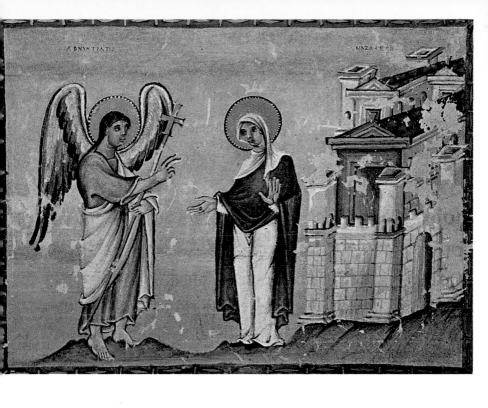

the tree that divides gabriel (here without
wings) from mary may be a reference to
both the tree of life in paradise and the
tree of temptation in the garden of eden.
mary is frequently contrasted with the
old-testament eve, since as mother of christ
she brought about the delivery of mankind
from the original sin of adam.

ivory book cover
late 11th century
staatliche museen, berlin

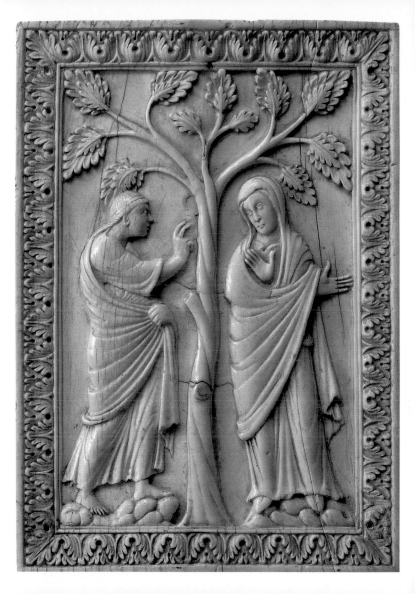

the dove (symbol of the holy spirit) had by
this time become a more common motif in
scenes of the annunciation. this, however,
is one of the earliest representations to
show the christ child brought down by the
dove: here we see his head and shoulders
peering out of a cloth hanging from the
dove's beak.

ivory relief
c.1100
staatliche museen, berlin

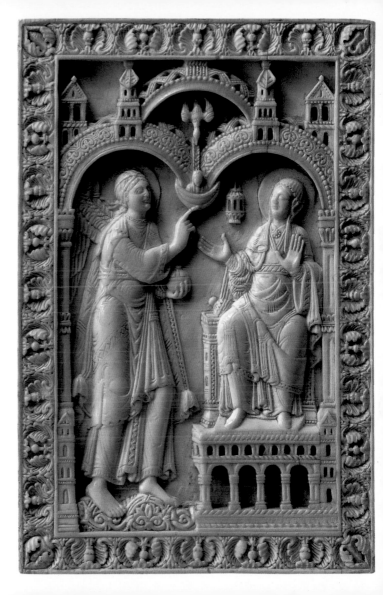

icon

early 12th century

gallery of icons, ohrid

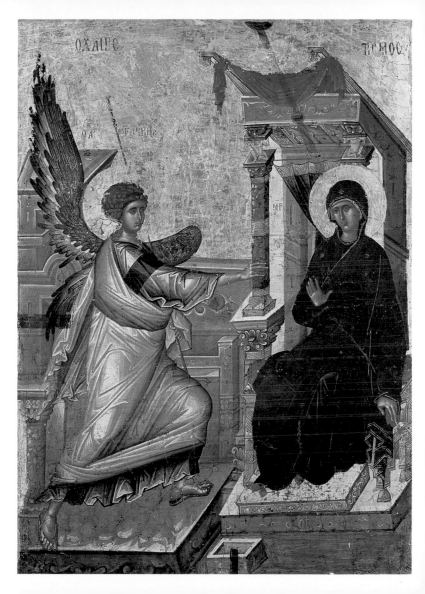

illuminated manuscript

c.1130–50

biblioteca vaticana, rome

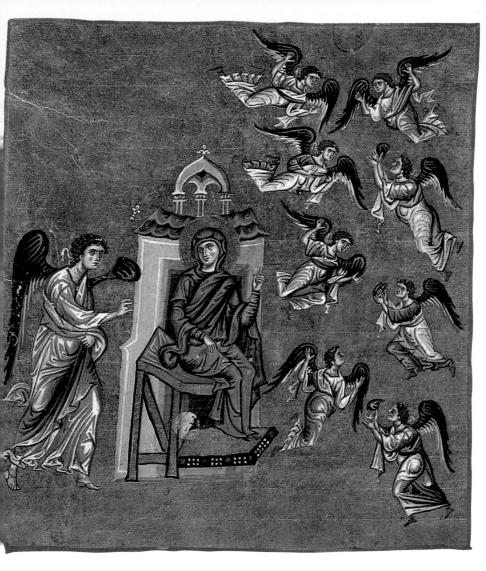

in this celebrated icon from the novgorod
school, the christ child is seen already
present within the virgin's body. this refers
to the orthodox belief that the incarnation
(the moment when mary conceived christ)
took place at the annunciation. it is also
one of the earliest scenes to show god
the father, here enthroned at the top
of the panel.

icon
12th century
tret'yakov gallery, moscow

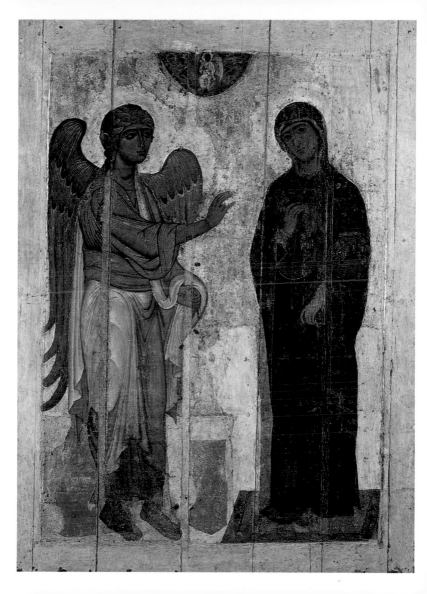

illuminated manuscript

c.1150

württembergische landesbibliothek, stuttgart

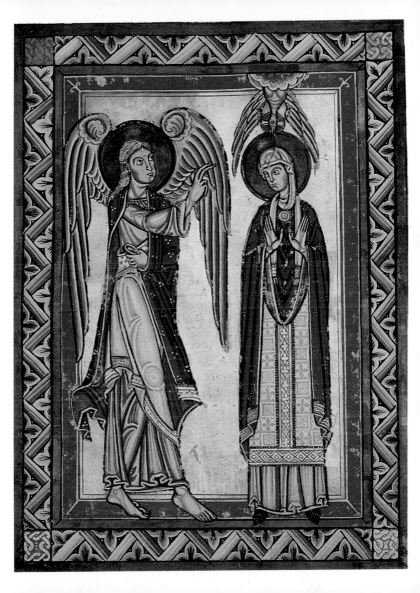

stained-glass window

mid-12th century

chartres cathedral

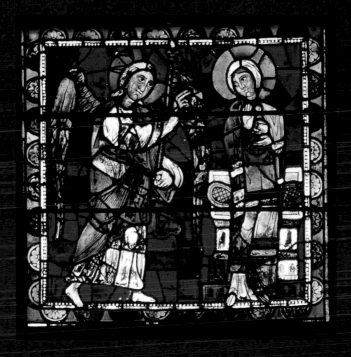

nicholas of verdun

enamel plaque

1181

klosterneuburg abbey

joseph master
stone portal figures
c.1245–55
reims cathedral

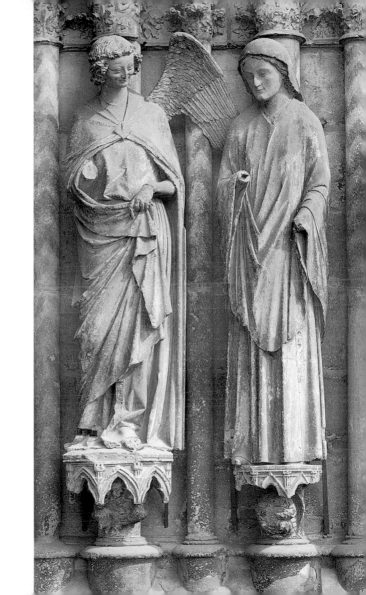

pietro cavallini

mosaic

c.1291

santa maria in trastevere, rome

(overleaf)

giotto

fresco

1306

scrovegni chapel, padua

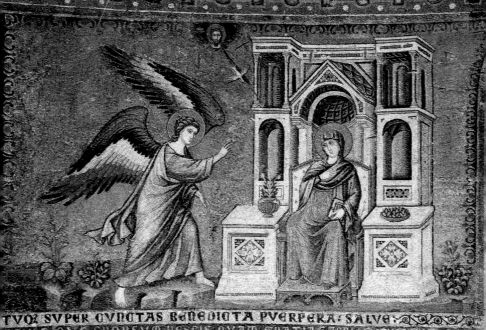

TVO₂ SVPER CVNCTAS BENEDICTA PVERPERA · SALVE ·
ROVLA CVE SPONSVM NESCIS QVAM GRATIA SACRI
A MINIS IRRADIAT · CELO MARIS ANDVE SYDVS ·

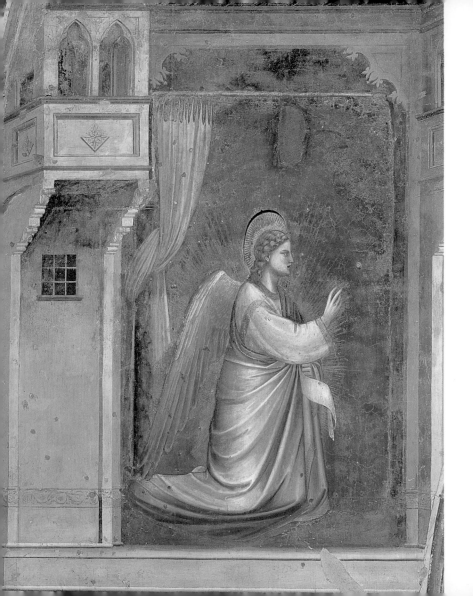

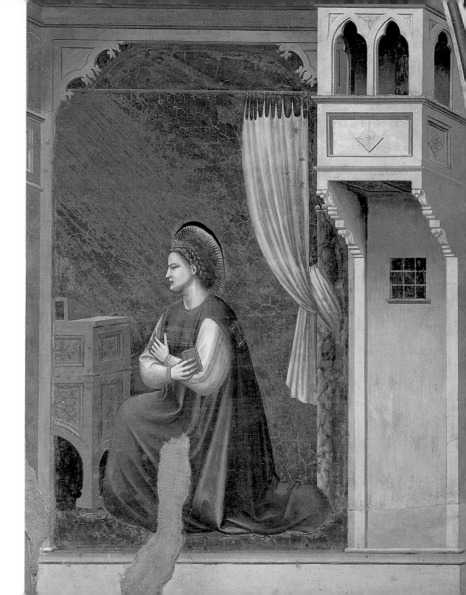

the virgin has been surprised in the act of
reading the book of isaiah. the prophecy at
7: 14 – 'behold, a virgin shall conceive and
bring forth a son, and his name shall be
called emmanuel' – is legible in latin in the
book which she clasps in one hand.

duccio
tempera on wood
1308–11
national gallery, london

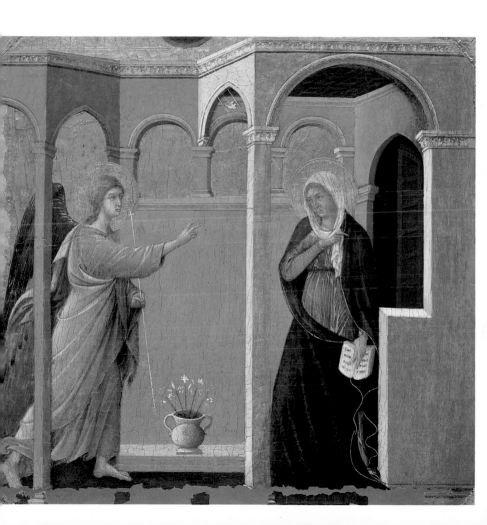

jean pucelle
illuminated manuscript
c.1325
cloisters collection,
metropolitan museum of art, new york

(overleaf)
bernardo daddi
tempera on wood
c.1330
louvre, paris

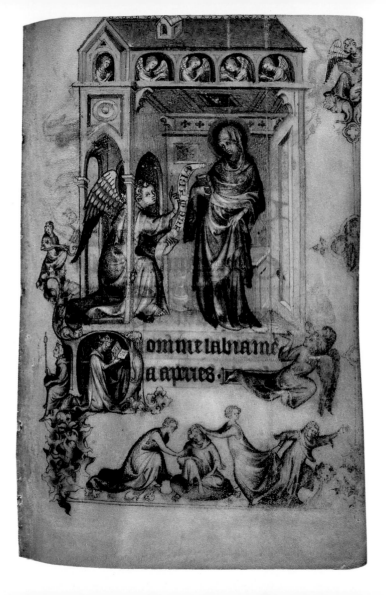

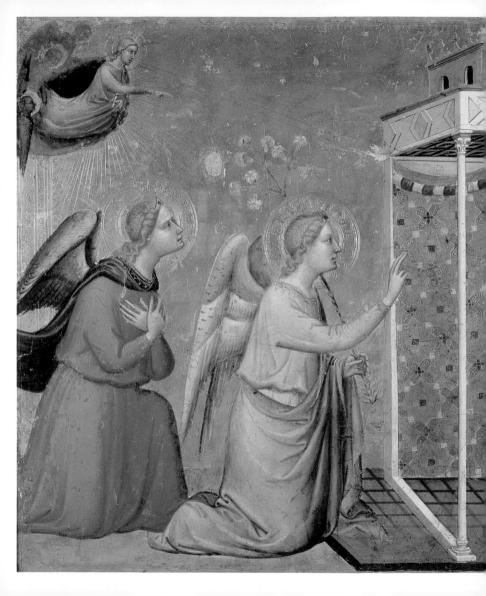

this most famous of annunciations was
probably the first time that the subject was
used as the central motif in an altarpiece –
an innovation particularly suited to siena
where the virgin was patron saint of the
city, and where simone worked. the lily in
the centre is one of the most common
symbols of mary's purity; the rarer olive
branch held by gabriel represents peace.

simone martini
tempera on wood
1333
uffizi, florence

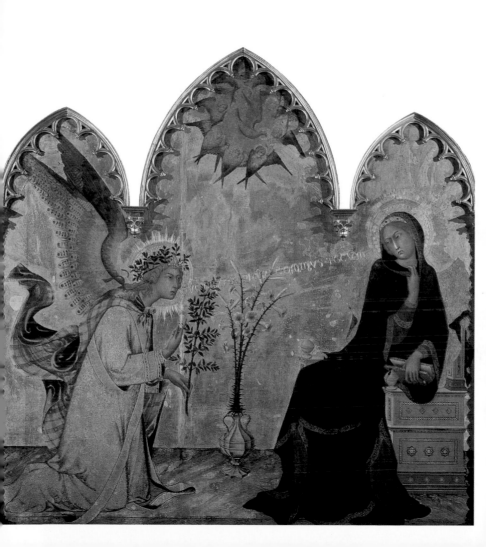

this masterpiece of the gothic style is
rich in christian imagery. the domed
romanesque building in the background
symbolizes the old testament, while the
elaborate gothic tabernacle in which the
virgin sits represents the new testament
which the annunciation introduces.

melchior broederlam
tempera on wood
1395–99
musée des beaux-arts, dijon

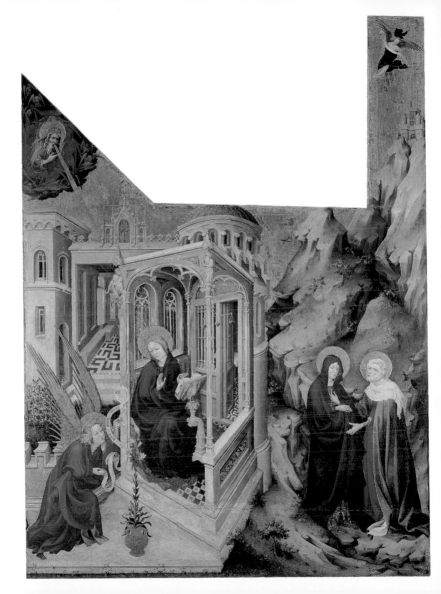

paul and jean de limbourg

illuminated manuscript

c.1411–16

musée condé, chantilly

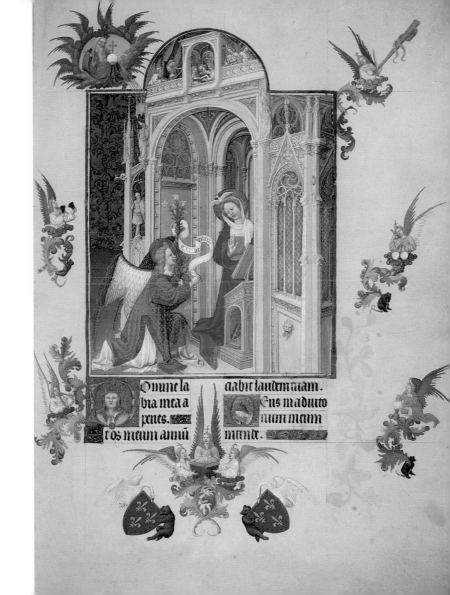

Ominne la aabit laudem meam.
bia mea a Eus madurto
pens. num meum
tos meum annu muntte.

gentile da fabriano

tempera on wood

c.1419

pinacoteca vaticana, rome

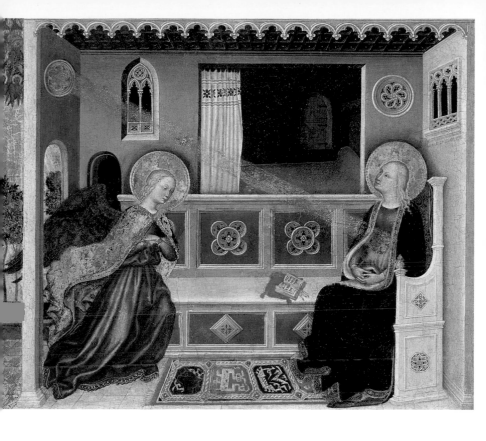

fifteenth-century theologians were
critical of the way some artists showed the
christ child floating down to earth – it
contradicted the doctrine that christ derived
his earthly form from mary. here campin
has kept the motif but makes the figure so
small that it is almost invisible. the
contemporary domestic setting was also
very innovative for its time.

robert campin
oil on wood
c.1425
cloisters collection,
metropolitan museum of art, new york

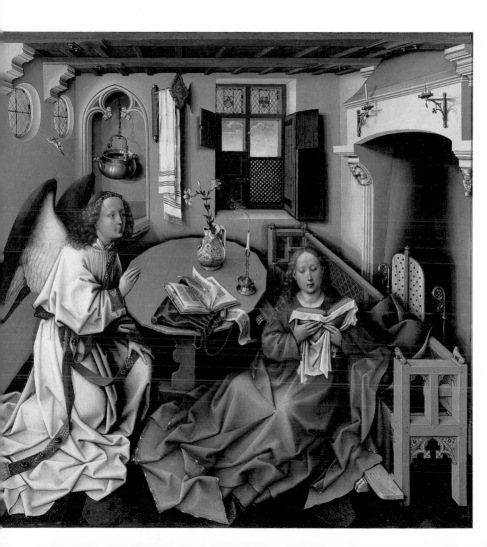

attributed to petrus christus

oil on wood

c.1425

metropolitan museum of art, new york

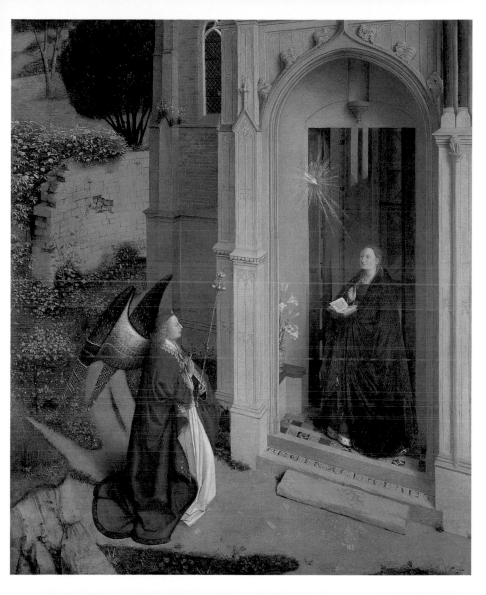

masolino

tempera on wood

c.1425–30

national gallery of art, washington dc

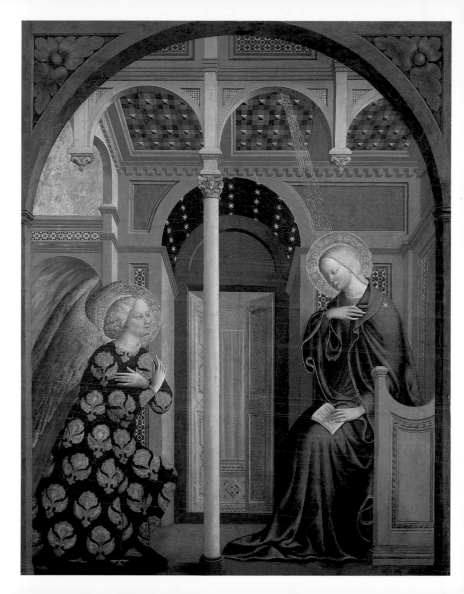

follower of rogier van der weyden

oil on wood

c.1432

metropolitan museum of art, new york

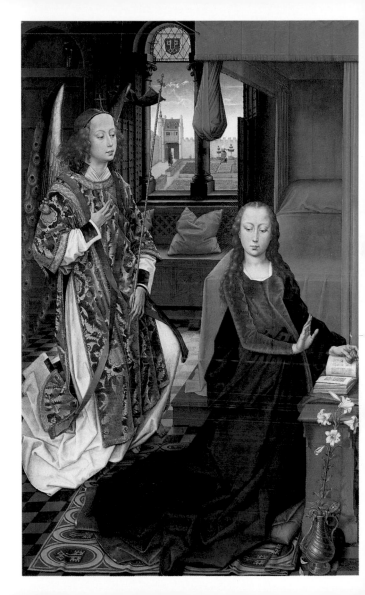

here the belief that mary rectified the sins
of adam and eve is made explicit: the artist
has depicted the expulsion from paradise
almost as if it were happening just beyond
her garden fence. this episode of the old
testament is frequently found alongside the
annunciation (see pp. 76, 106 and 210).

fra angelico
tempera on wood
c.1432
museo diocesano, cortona

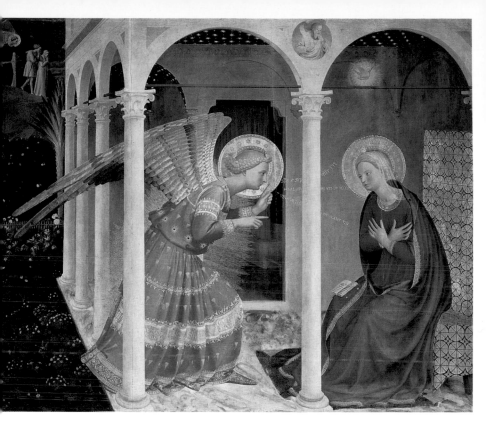

gabriel and mary make the traditional
verbal exchange found in saint luke's
gospel. the angel greets the virgin with
the words 'hail, thou art full of grace'.
mary's impeccably humble reply – 'behold
the handmaid of the lord' – is here written
upside down as if to be read by god
himself in heaven.

jan van eyck
oil on canvas transferred from wood
c.1434–6
national gallery of art, washington dc

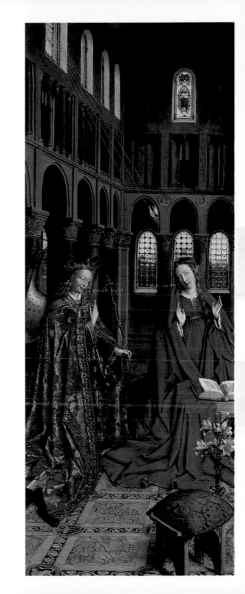

donatello

gilded sandstone

1430s

santa croce, florence

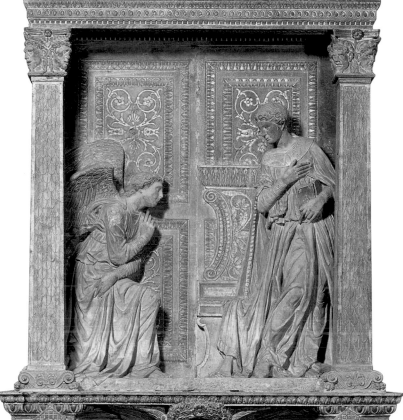

rogier van der weyden
oil on wood
c.1435
louvre, paris

(overleaf)
jan van eyck
oil on wood
c.1435
thyssen-bornemisza collection, madrid

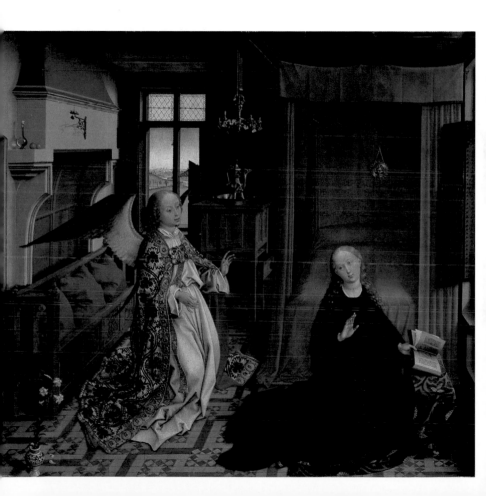

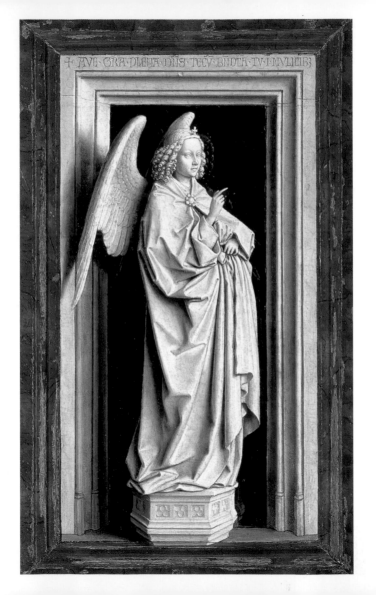

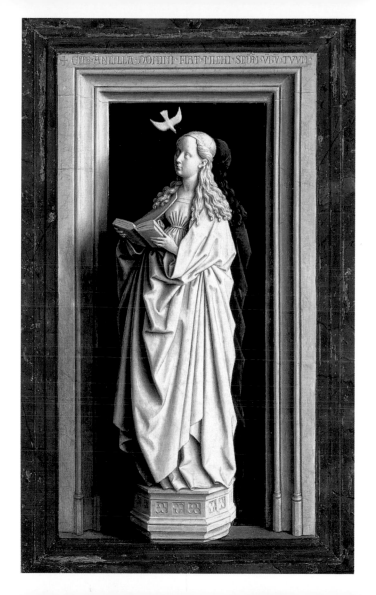

rhenish school
painted wood with clay figures
c.1440
diocesan museum, cologne

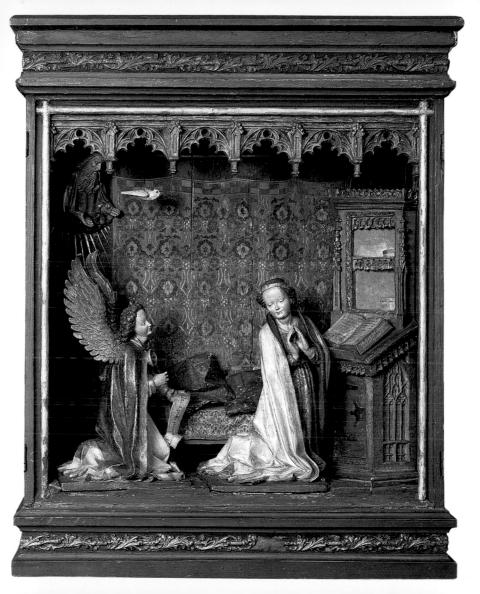

this beautifully simple representation of the
annunciation evokes the atmosphere of the
quiet cloister where the fresco is to be
found. the artist has eliminated all sense of
movement in order to convey the stillness
and humility of the sacred story.

fra angelico
fresco
c.1441–3
museo di san marco, florence

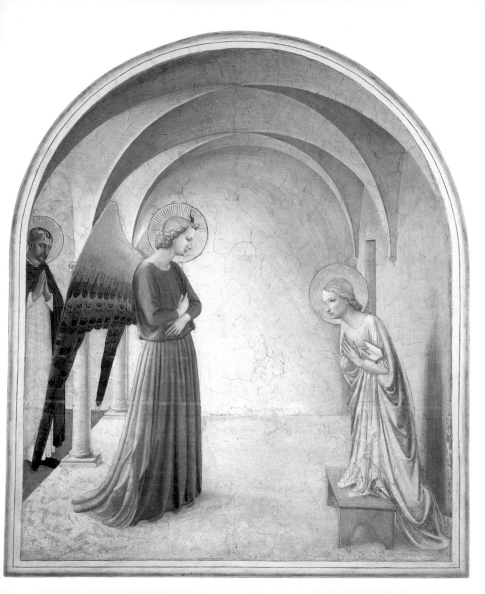

master of the aix annunciation
oil on wood
c.1442–5
sainte marie madeleine,
aix-en-provence

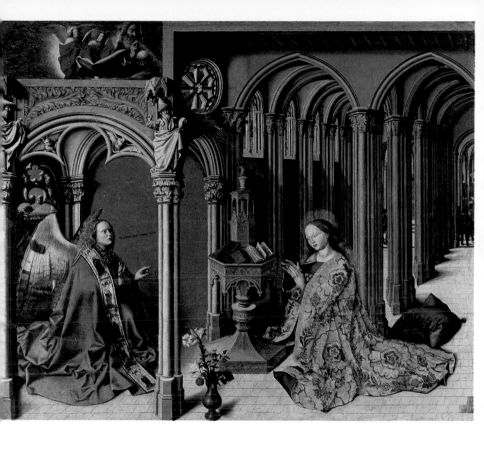

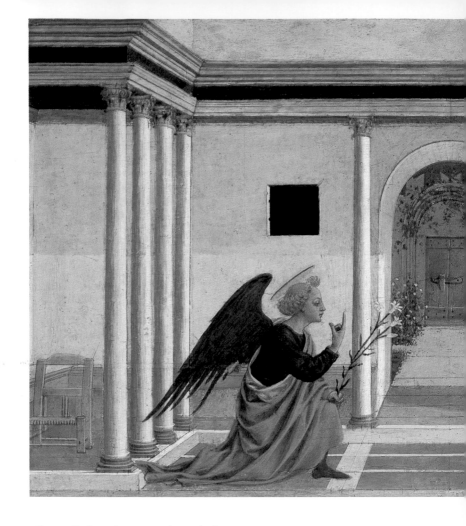

the walled garden, seen through the
archway in the centre of this painting, is a
common symbol of mary's virginity.

domenico veneziano

tempera on wood

c.1445

fitzwilliam museum, cambridge

dirck bouts

oil on wood

c.1445

prado, madrid

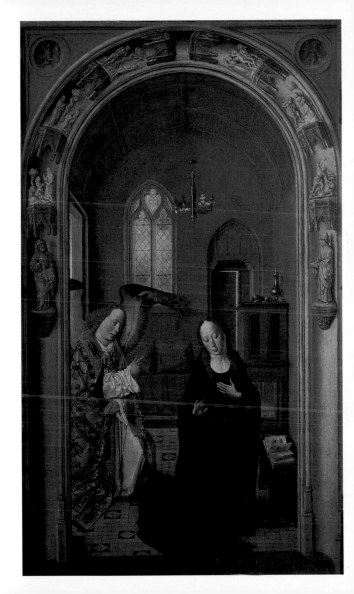

giovanni di paolo

tempera on wood

c.1445

national gallery of art, washington dc

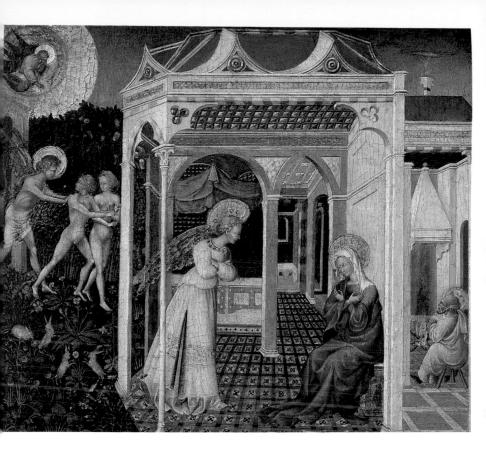

fra filippo lippi
tempera on wood
c.1445
alte pinakothek, munich

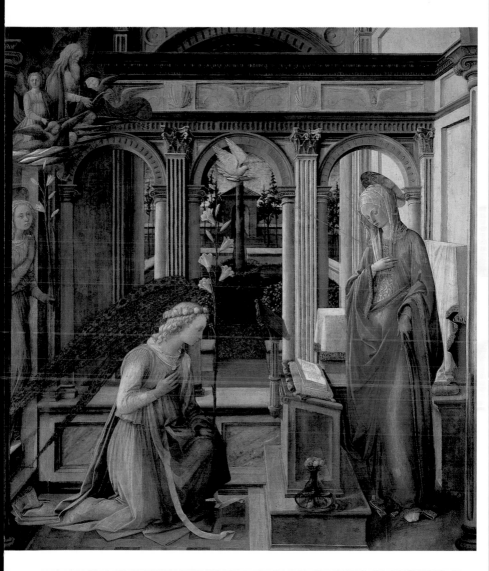

stained-glass window

1448–56

bourges cathedral

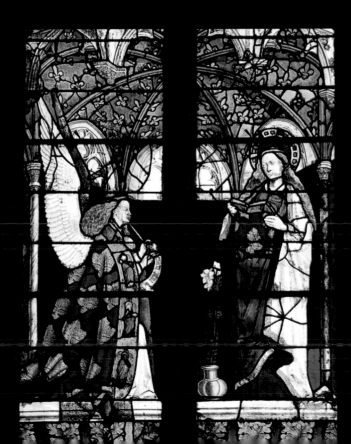

giusto d'alemagna

fresco

c.1451

santa maria di castello, genoa

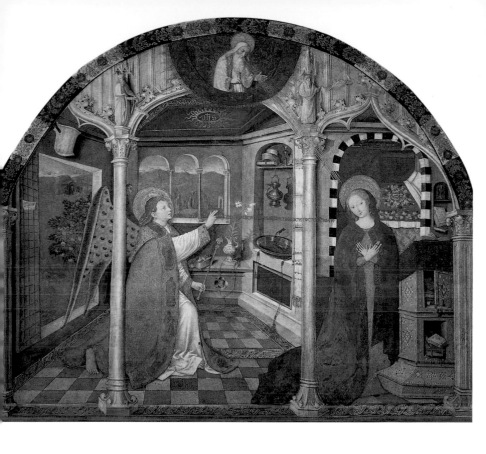

fra angelico
tempera on wood
c.1451
museo di san marco, florence

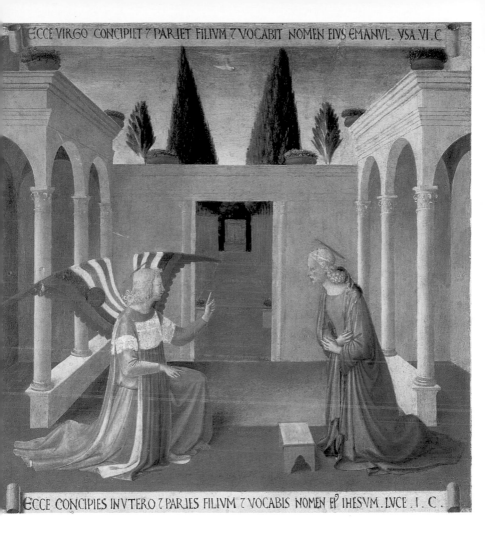

ECCE VIRGO CONCIPIET 7 PARIET FILIVM 7 VOCABIT NOMEN EIVS EMANVL. YSA. VI. C

ECCE CONCIPIES INVTERO 7 PARIES FILIVM 7 VOCABIS NOMEN E IHESVM. LVCE. I. C

jean fouquet
illuminated manuscript
c.1452
musée condé, chantilly

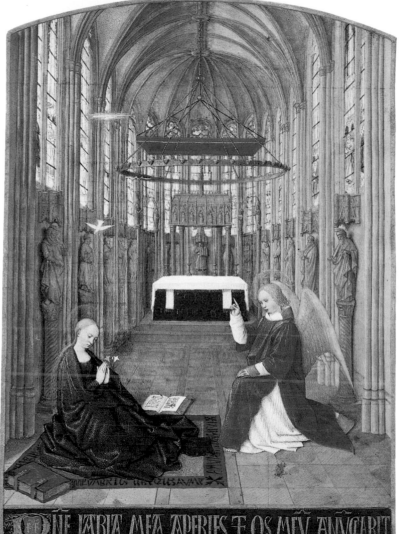

ONE LABIA MEA APERIES ꞇ OS MEV ANVCABIT

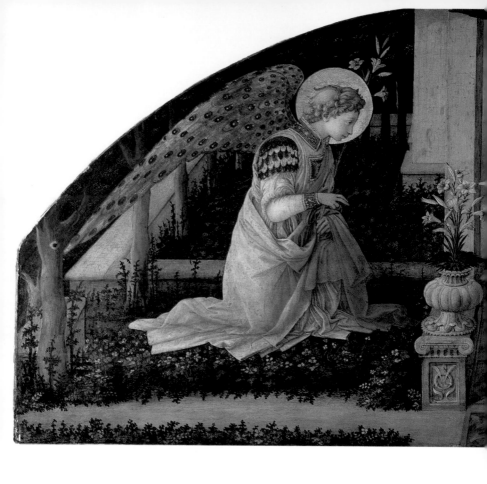

fra filippo lippi

tempera on wood

c.1455–60

national gallery, london

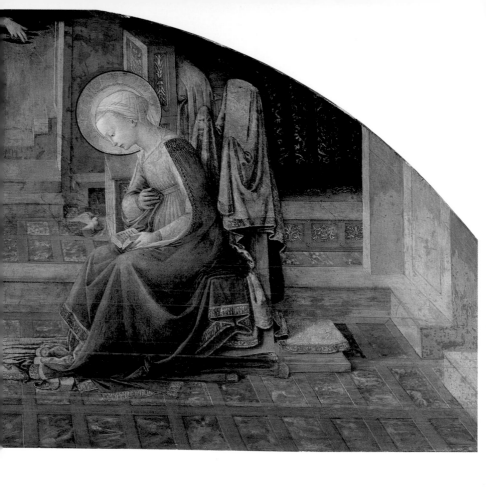

piero della francesca
fresco
c.1457–8
san francesco, arezzo

(overleaf)
martin schongauer
tempera and oil on wood
c.1465–70
musée d'unterlinden, colmar

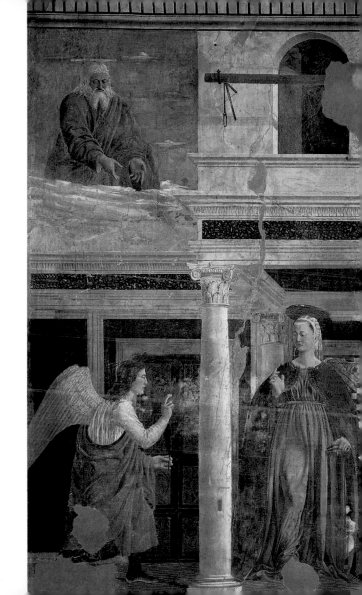

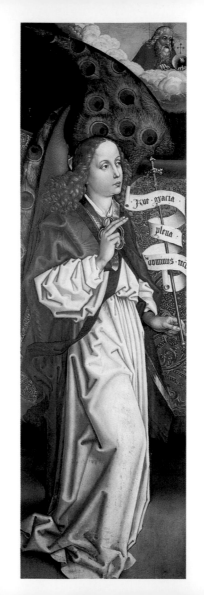

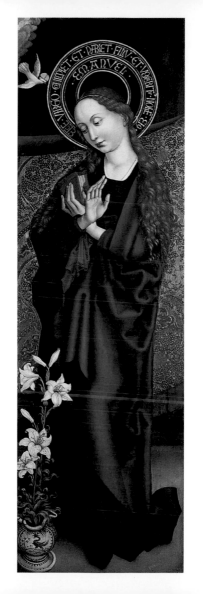

niccolò da foligno
tempera on canvas
1466
galleria nazionale dell'umbria, perugia

(overleaf)
cosimo tura
tempera on canvas
1469
galleria nazionale, ferrara

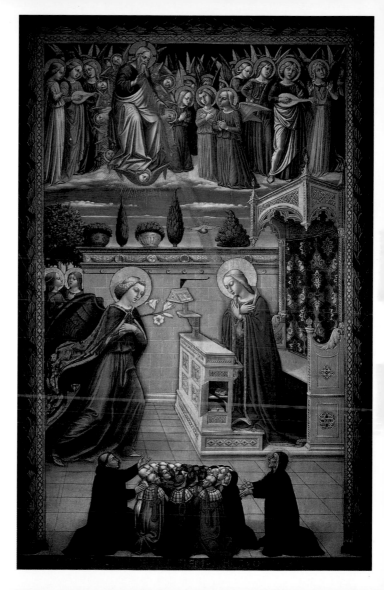

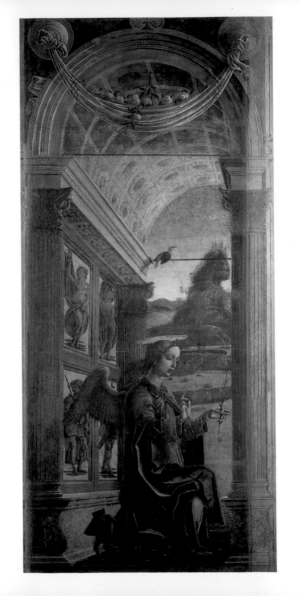

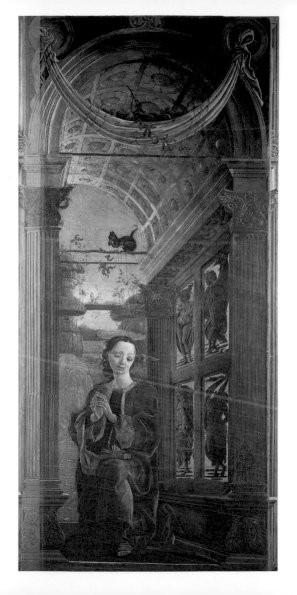

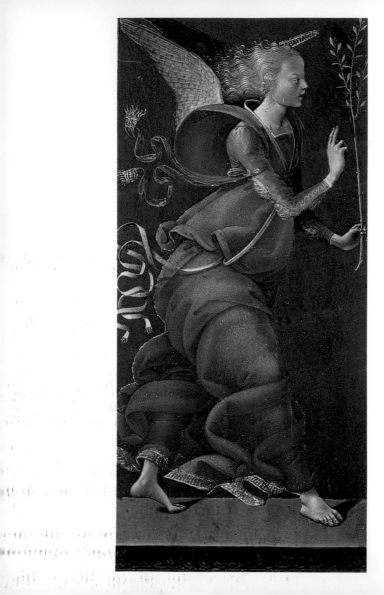

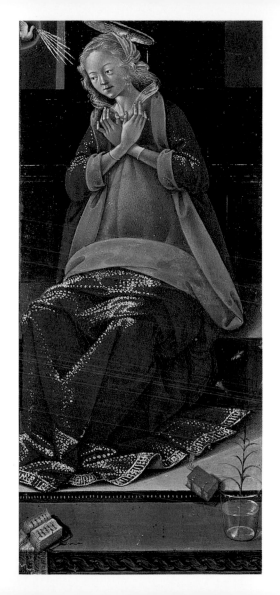

(previous pages)
bartolomeo della gatta
oil on wood
c.1470–80
museo diocesano, volterra

francesco del cossa
tempera on wood
c.1472
gemäldegalerie, dresden

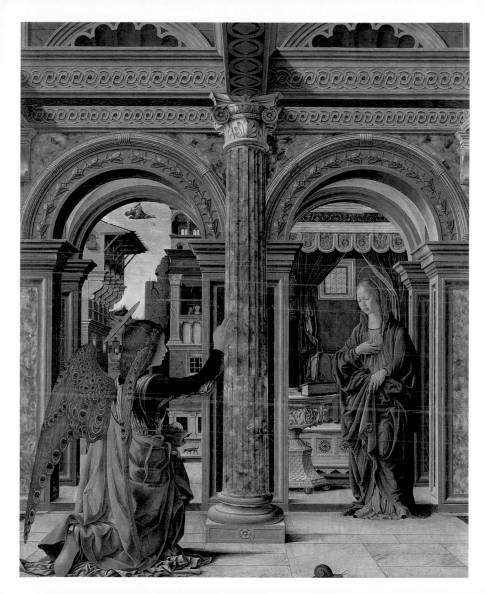

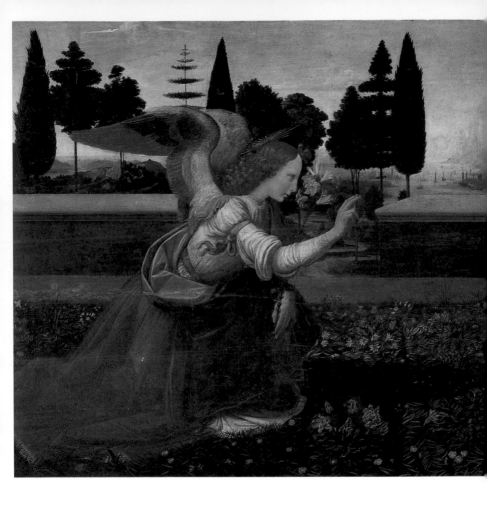

leonardo da vinci

oil on wood

c.1472

uffizi, florence

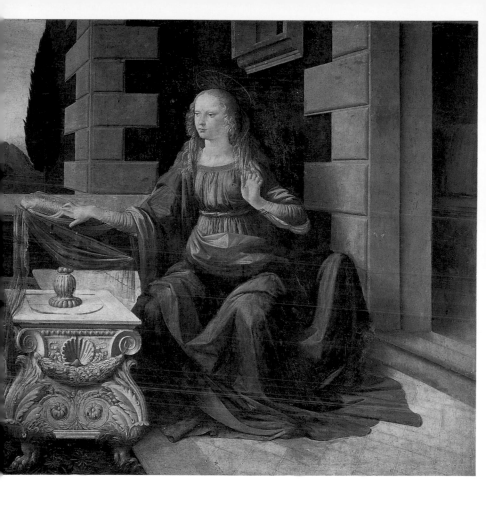

andrea della robbia

glazed terracotta

c.1475

chiesa maggiore, la verna

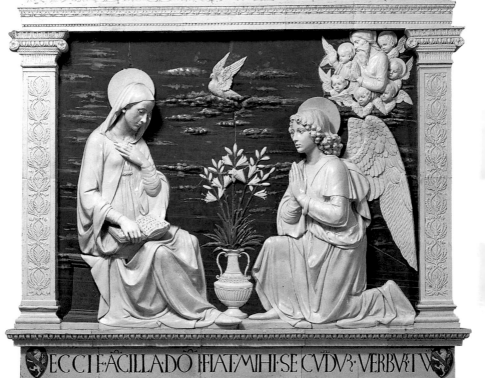

ECCEĀCILLADŌ IFIAT MIHI SECVDVR VERBVŤVȚ

lorenzo di credi

oil on wood

c.1480–85

uffizi, florence

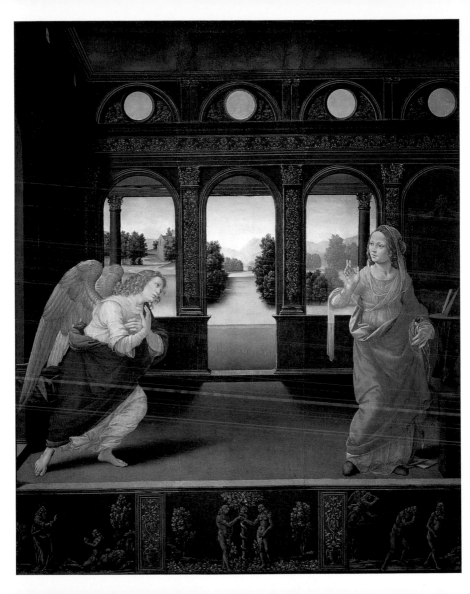

in this very public annunciation crivelli
takes the unusual step of showing a saint
alongside the archangel gabriel. this is
emidius, patron saint of the town of ascoli,
a model of which he holds in his hands. the
town was granted limited self-government
by pope sixtus iv in 1482, and the news
reached the town on the feast day of the
annunciation (25 march). this painting
celebrates that event.

carlo crivelli
oil and tempera on wood
1486
national gallery, london

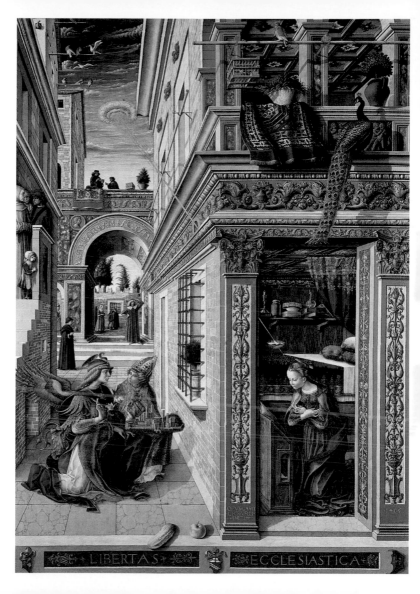

illuminated manuscript
late 15th century
museé de cluny, paris

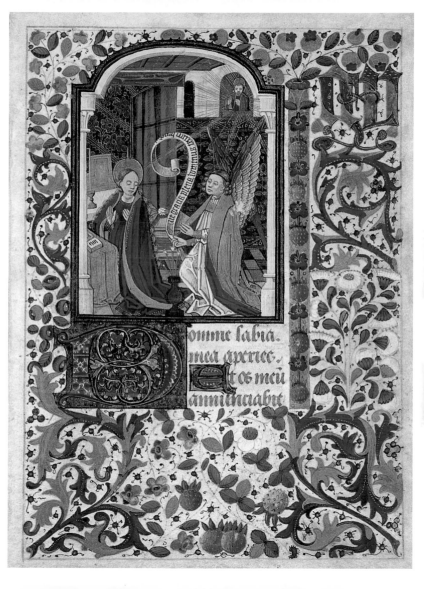

sandro botticelli
oil on wood
1489
uffizi, florence

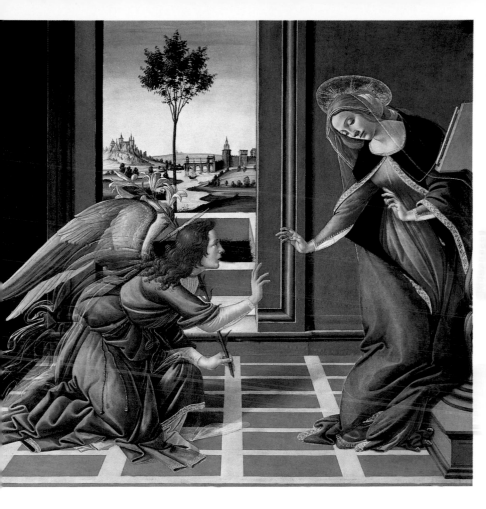

the divine breath that so vividly emerges
from god the father and curves down
towards the virgin expresses in visual terms
the concept of the incarnation as 'the word
of god made flesh'.

english school
alabaster relief
late 15th century
musée de cluny, paris

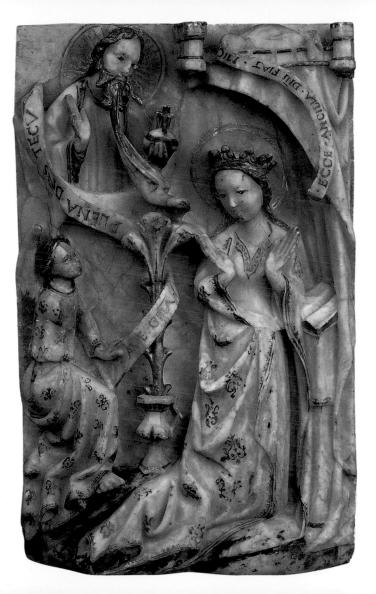

carlo braccesco
oil on wood
c.1494
louvre, paris

(overleaf)
albrecht dürer
woodcuts
1505 and 1511

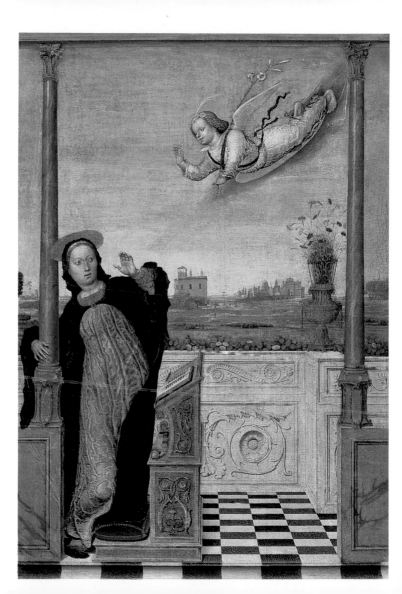

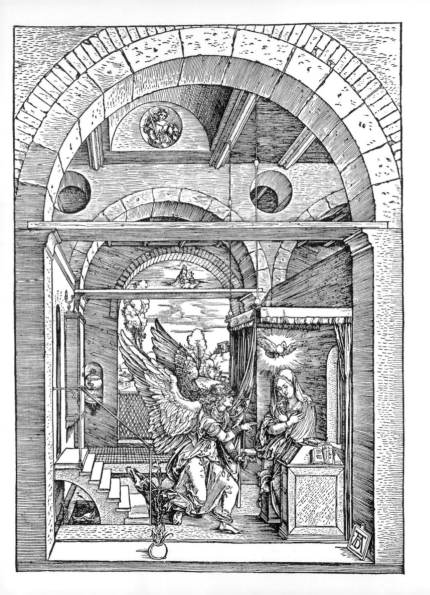

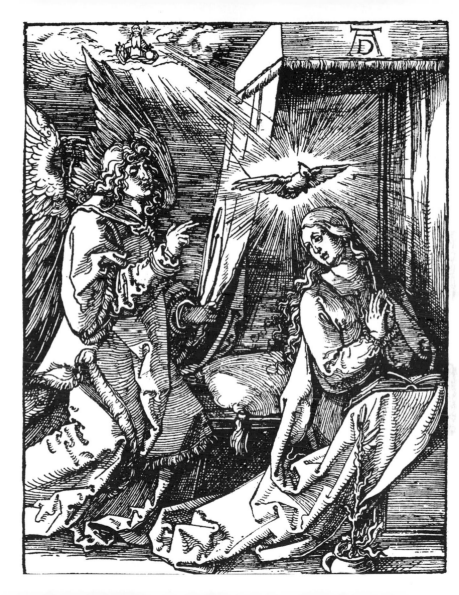

andrea solario

tempera and oil on wood

1506

louvre, paris

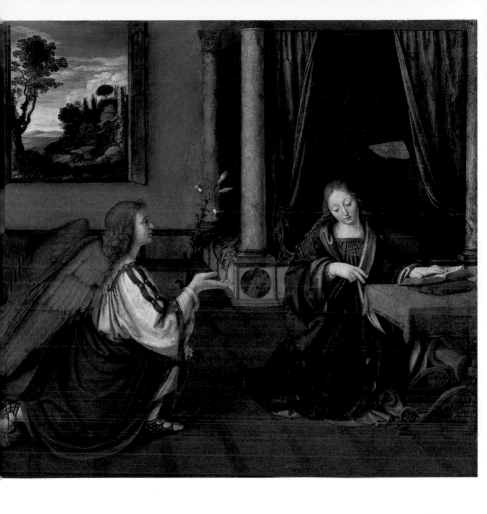

gerard david

oil on wood

c.1510

städelsches kunstinstitut, frankfurt am main

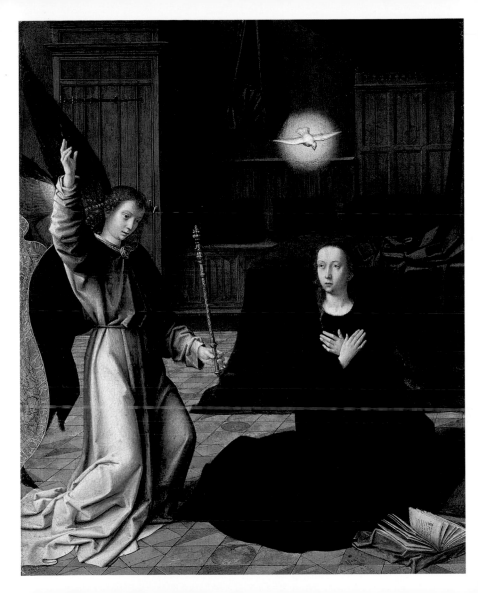

gaudenzio ferrari

oil on wood

c. 1512–13

gemäldegalerie, berlin

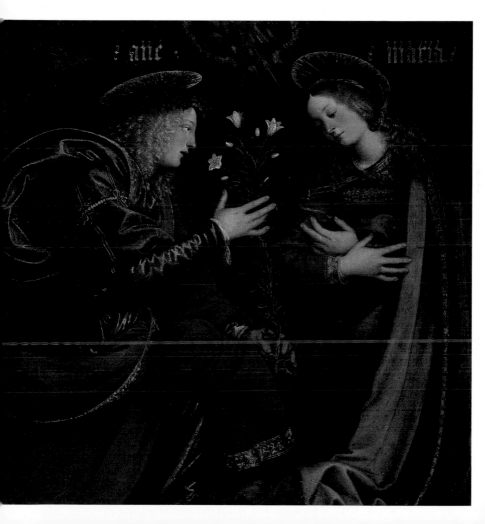

matthias grünewald

oil on wood

1515

musée d'unterlinden, colmar

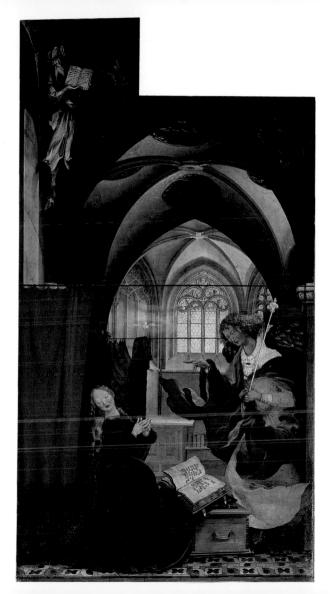

veit stoss

painted wood

1517–18

st lorenz, nuremberg

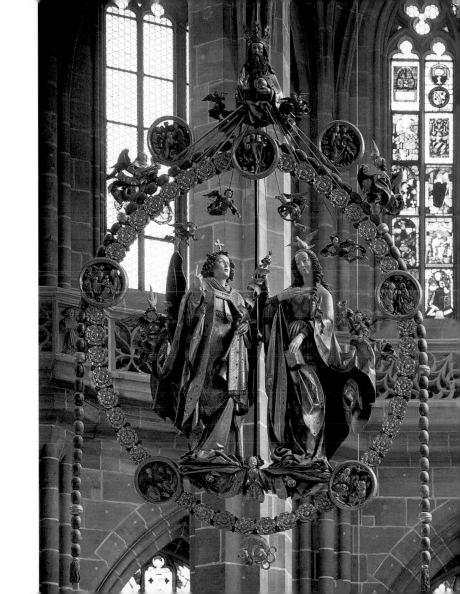

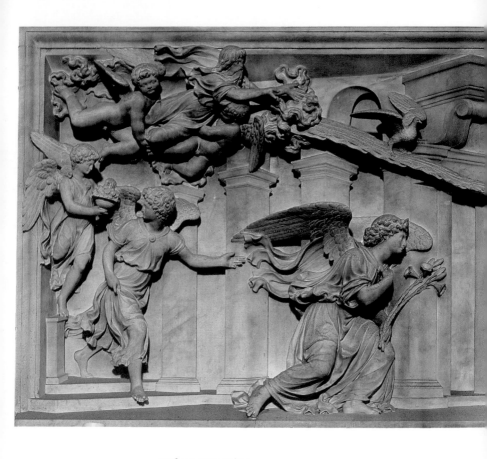

andrea sansovino

marble relief

1518–22

santuario della santa casa, loreto

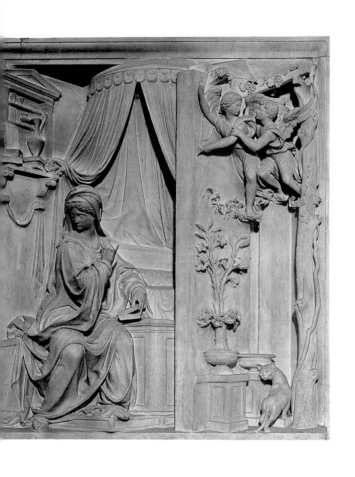

gerard horenbout
illuminated manuscript
c.1519–20
british library, london

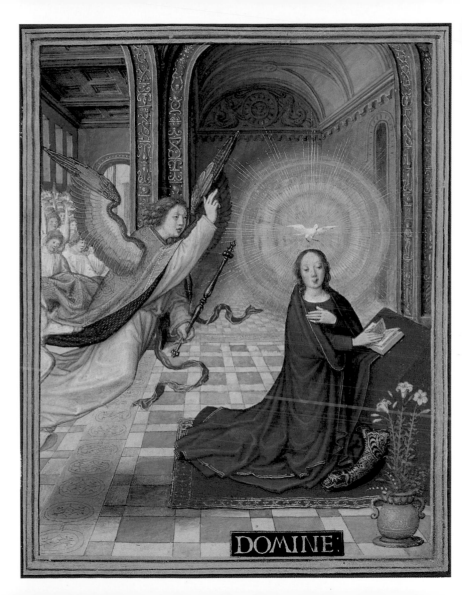

DOMINE:

french school

tapestry

c.1520–30

palais du tau, reims

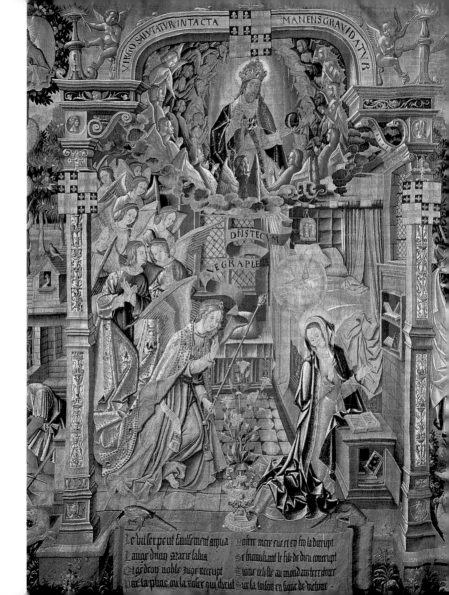

VIRGO SALVIATVR INTACTA MANENS GRAVIDATVR

DNS TECVM

NE GRA PLE

Le bil ser peut sanlement arpua voltre mere eut et en fin la decrupt
L auge dnng Marie salus se thanulant le fil de dieu conecupt
C gedcon noble Juge receupt une cela fie au mondam territour
per la pluie ou la rolee qui thut cur la toison en tigne de victoire

lucas van leyden

oil on wood

1522

alte pinakothek, munich

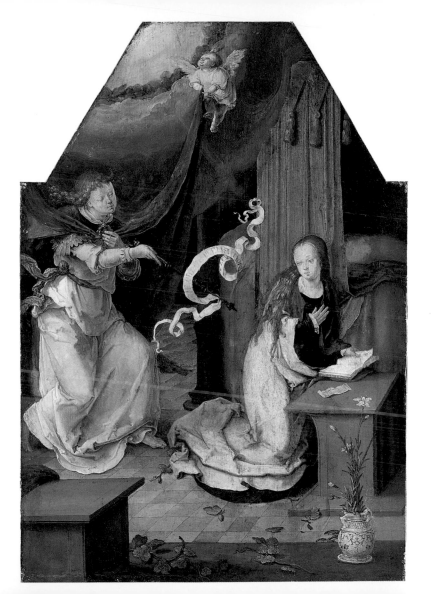

jacopo pontormo
fresco
1525–8
santa felicità, florence

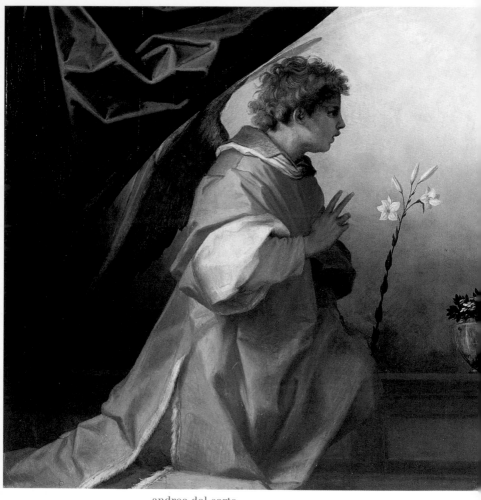

andrea del sarto

tempera on wood

1528

palazzo pitti, florence

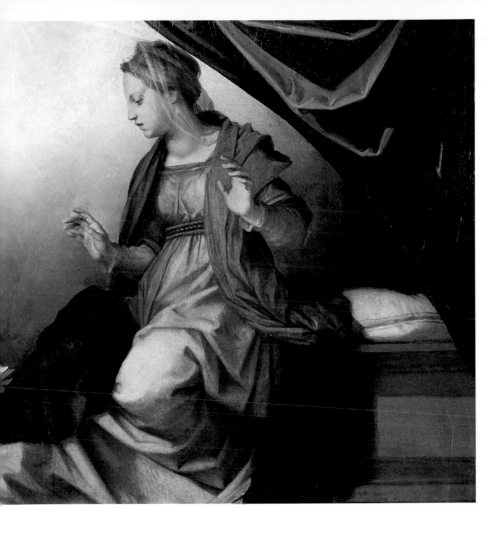

lotto shows mary turning away from her
prie-dieu in an attitude of awe and surprise
at the angel who has just alighted outside
her bedroom. no less startled is the cat,
which leaps across the floor with raised tail
and arched back.

lorenzo lotto
oil on canvas
1534–5
museo civico, recanati

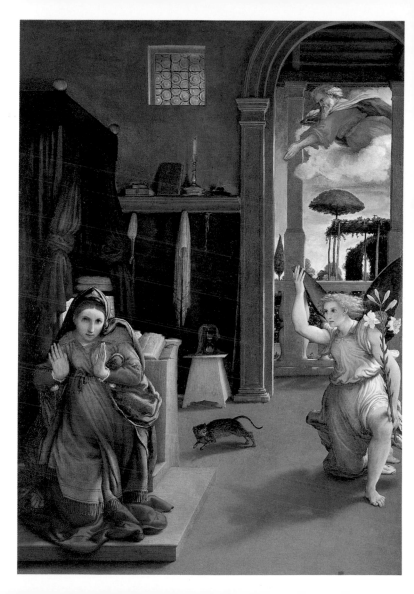

girolamo mazzola bedoli

oil on canvas

c.1539

pinacoteca ambrosiana, milan

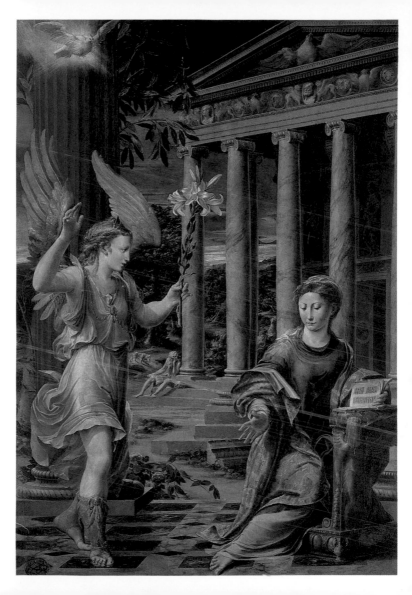

titian
oil on canvas
c.1540
scuola grande di san rocco, venice

(overleaf)
paris bordone
oil on canvas
1545–50
musée des beaux-arts, caen

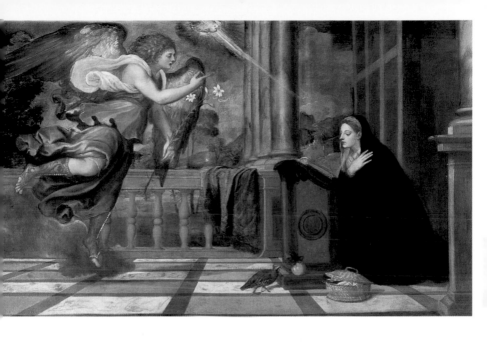

domenico beccafumi

oil on wood

1546

san martino, sarteano

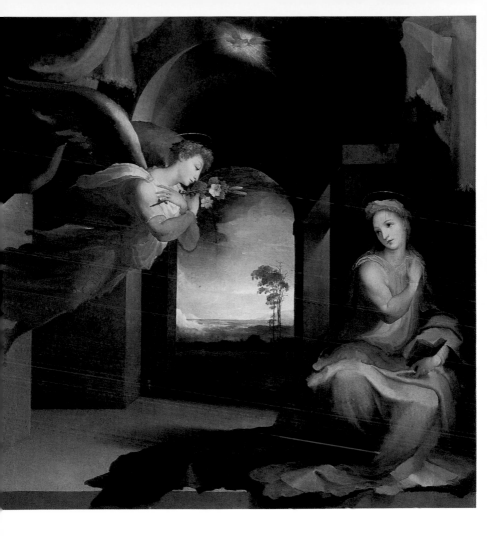

michelangelo
black chalk on paper
1547–50
uffizi, florence

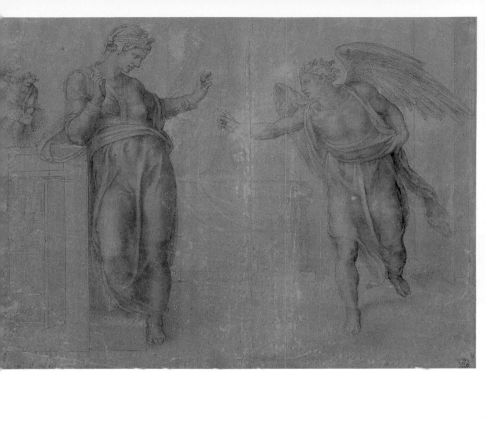

the 'overshadowing' of mary by the
holy spirit is here taken to an extreme in
the lambent, angel-filled cloud which
descends from an unseen source towards
the kneeling mary.

paolo veronese
oil on canvas
c.1551–6
uffizi, florence

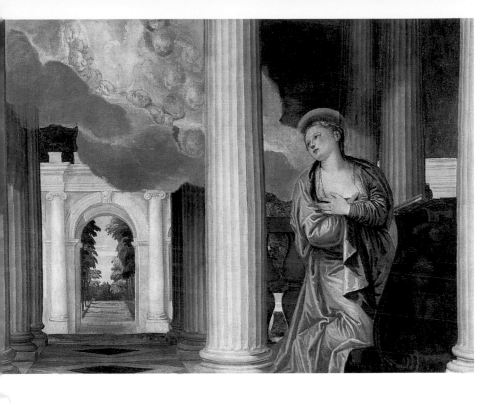

federico barocci

oil on canvas

c.1582

palazzo ducale, urbino

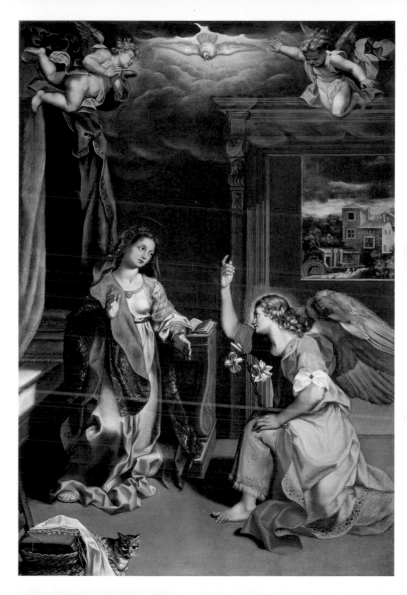

while reading in her bedchamber,
the virgin is surprised by the archangel
gabriel and a whole stream of cherubs
pouring into the room. in contrast to the
splendour of many contemporary scenes of
the annunciation, mary's house is here
shown as rather decayed. outside, joseph
works on his carpentry, unaware of the
momentous events taking place within.

jacopo tintoretto
oil on canvas
1583–7
scuola grande di san rocco, venice

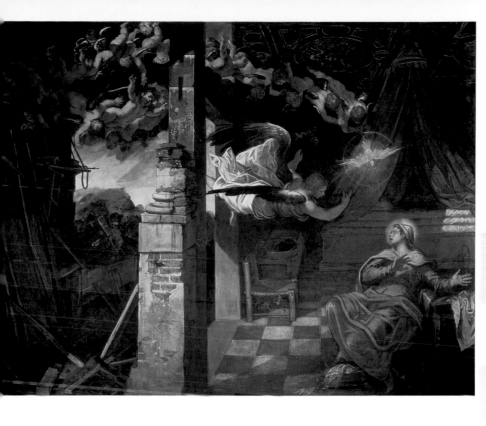

el greco

oil on canvas

1596–1600

prado, madrid

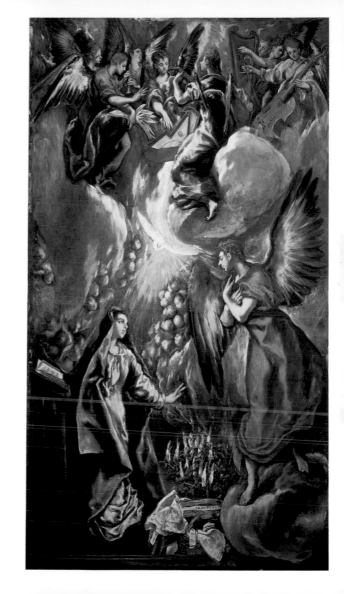

in counter-reformation art, gabriel is
generally accompanied by a retinue of putti
or other angels; they serve to emphasize his
importance as a messenger from on high.

peter paul rubens
oil on canvas
1609–10
kunsthistorisches museum, vienna

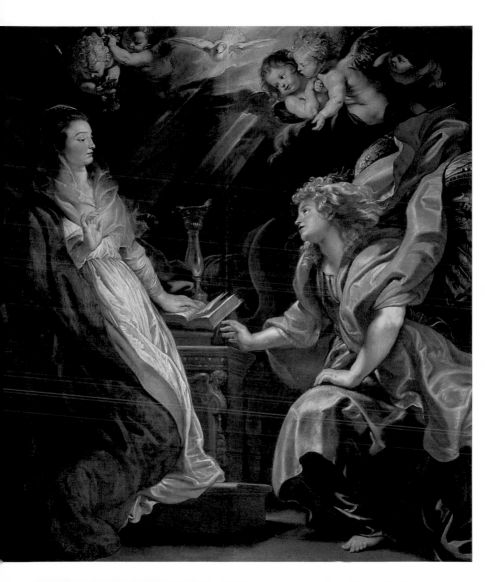

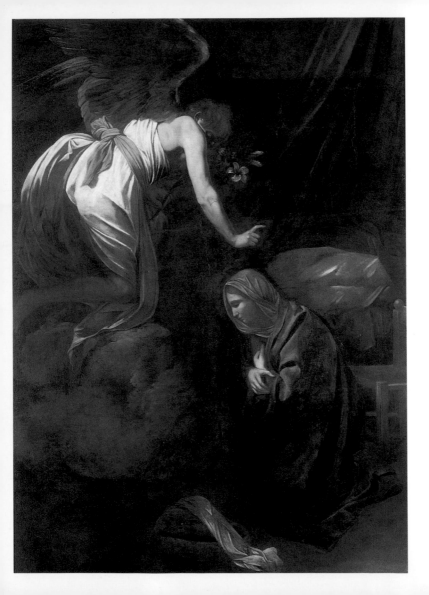

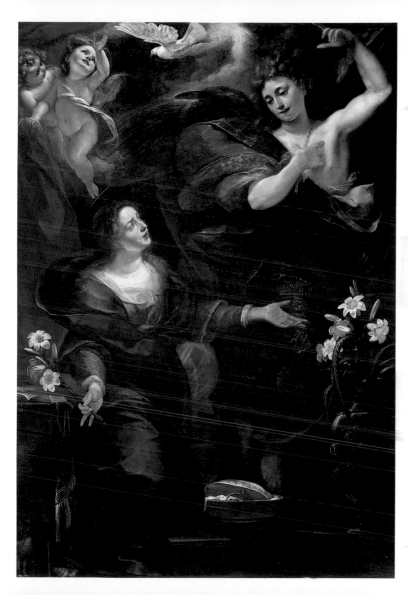

(previous pages)
caravaggio
oil on canvas
c.1609–10
musée des beaux-arts, nancy

giulio cesare procaccini
oil on canvas
c.1620
louvre, paris

orazio gentileschi
oil on canvas
1623
galleria sabauda, turin

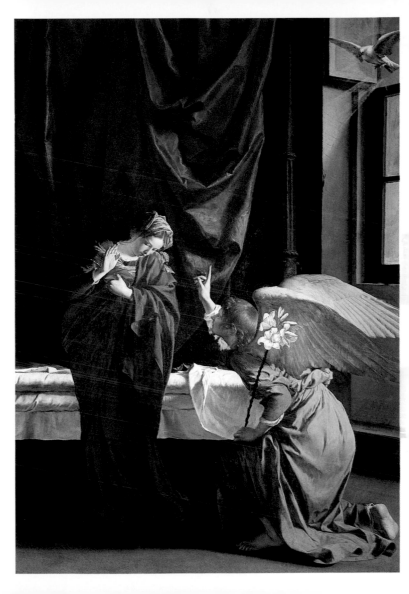

attributed to charles mellin

oil on canvas

c.1627

musée condé, chantilly

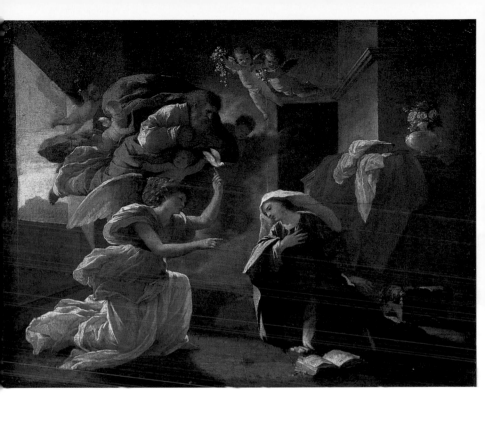

simon vouet

oil on wood

c.1630

uffizi, florence

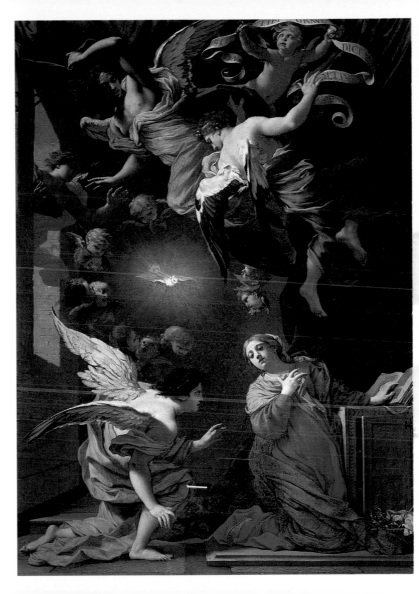

guido reni

oil on canvas

1631–2

louvre, paris

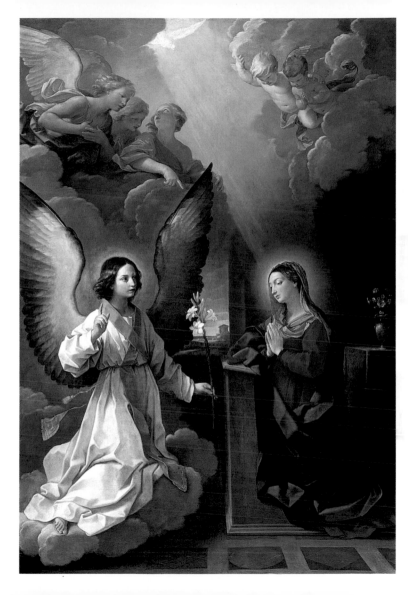

cornelis van poelenburgh

oil on copper

1635

kunsthistorisches museum, vienna

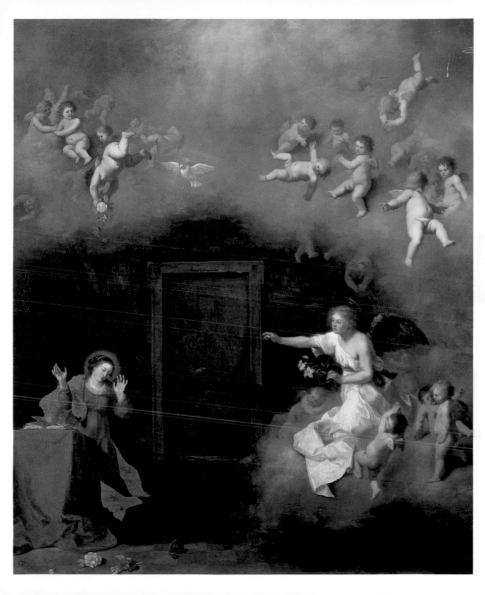

francisco de zurbarán

oil on canvas

1638–9

musée de grenoble

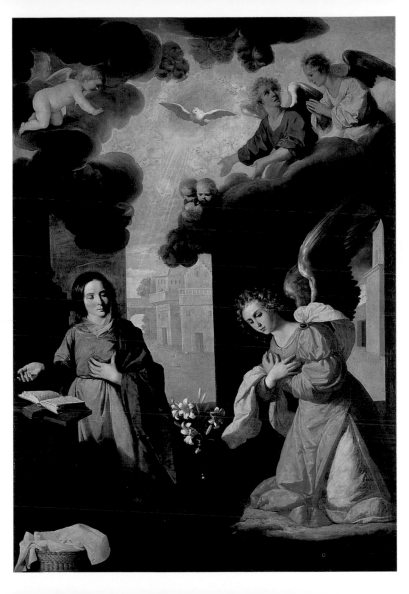

hendrick bloemaert
ink and wash heightened
with white on paper
c.1640
schlossmuseum, weimar

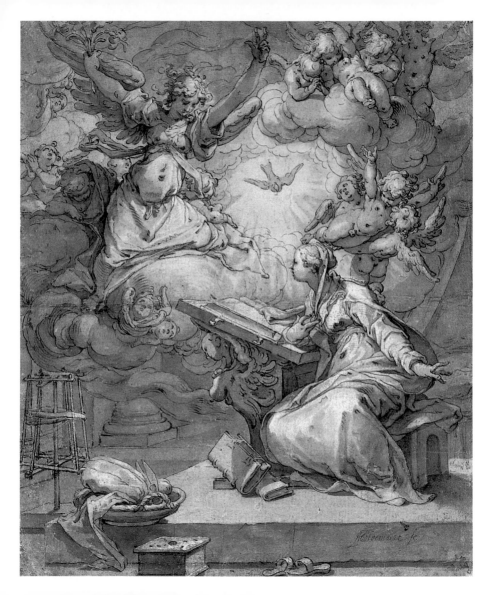

matthias stomer

oil on canvas

c.1640

private collection

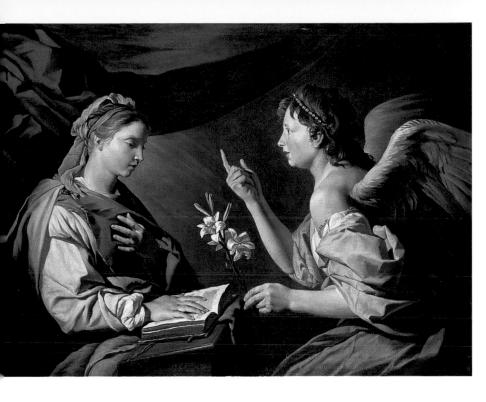

bernardo strozzi

oil on canvas

c.1640

szépmüvészeti múzeum, budapest

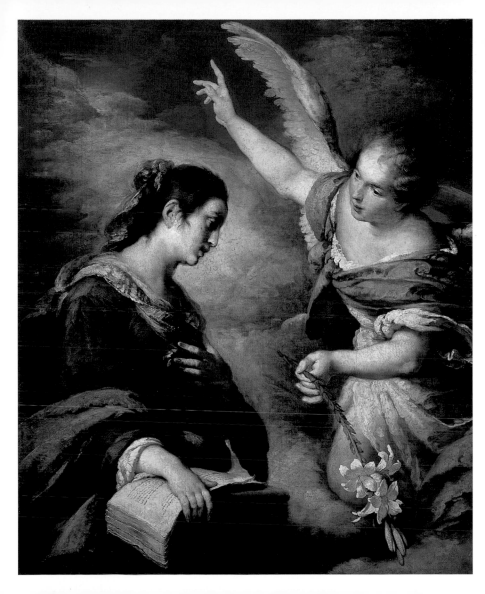

philippe de champaigne
oil on canvas
c.1645
wallace collection, london

PHAIDON PRESS LIMITED

Regent's Wharf

All Saints Street

London N1 9PA

PHAIDON PRESS INC.

180 Varick Street

New York

NY 10014

Dear Reader, Books by Phaidon are recognised world-wide for their beauty, scholarship and elegance. We invite you to return this card with your name and e-mail address so that we can keep you informed of our new publications, special offers and events. Alternatively, visit us at **www.phaidon.com** to see our entire list of books, videos and stationery. Register on-line to be included on our regular e-newsletters.

Subjects in which I have a special interest

☐ Art ☐ Contemporary Art ☐ Architecture ☐ Design ☐ Photography

☐ Music ☐ Art Videos ☐ Fashion ☐ Decorative Arts ☐ *Please send me a complimentary catalogue*

Name Mr/Miss/Ms Initial Surname

No./Street

City

Post code/Zip code Country

E-mail

This is not an order form. To order please contact Customer Services at the appropriate address overleaf.

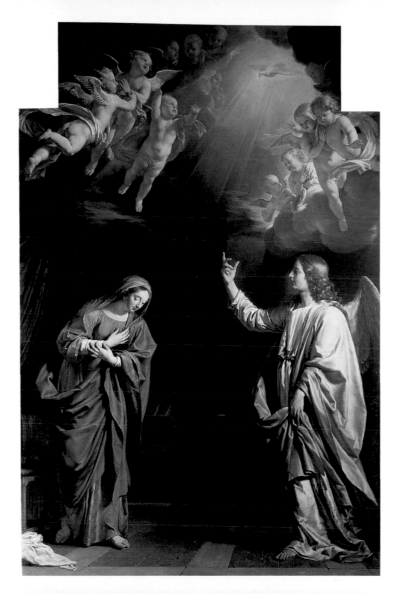

nicolas poussin

oil on canvas

1657

national gallery, london

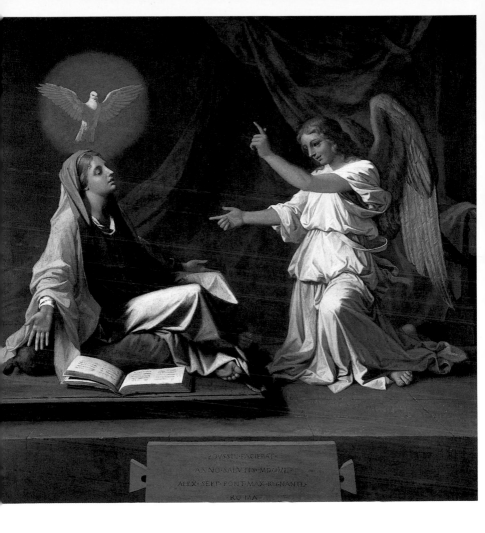

bartolomé esteban murillo

oil on canvas

c.1665–70

wallace collection, london

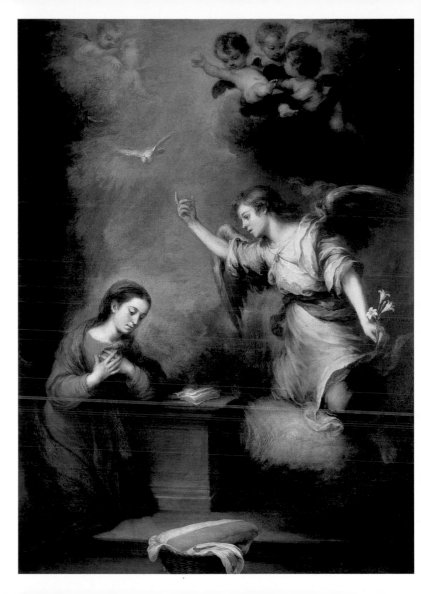

luca giordano

oil on canvas

1672

metropolitan museum of art, new york

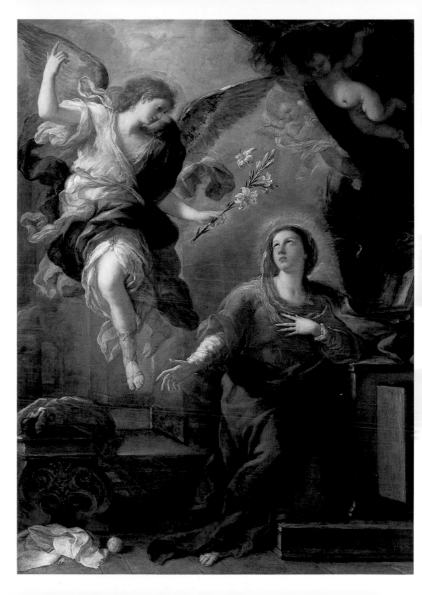

charles de la fosse

oil on canvas

c.1680–9

louvre, paris

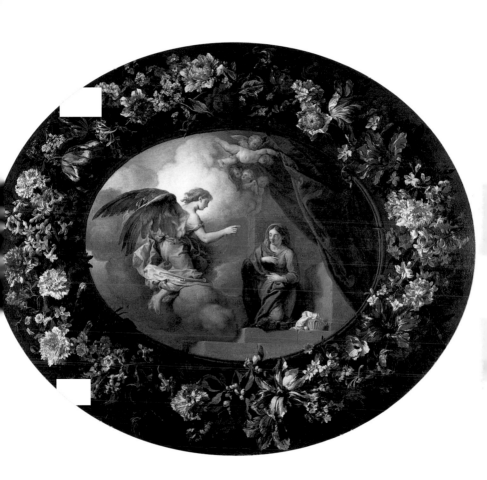

giovanni battista tiepolo

oil on canvas

1724–5

hermitage, st petersburg

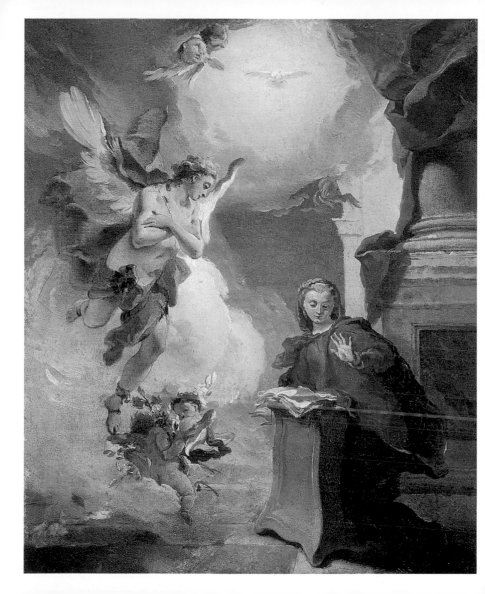

agostino masucci

oil on canvas

1742

minneapolis institute of arts

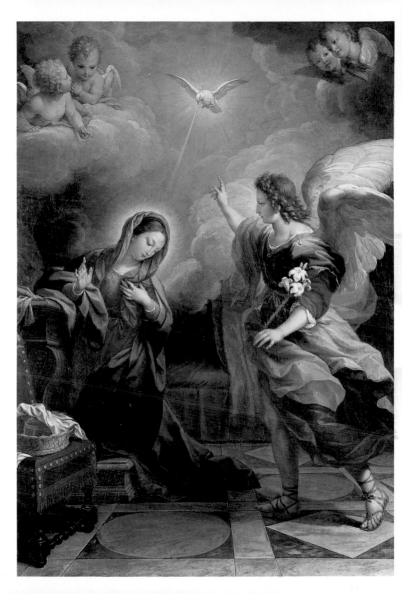

franz anton maulbertsch

oil on canvas

c.1754

louvre, paris

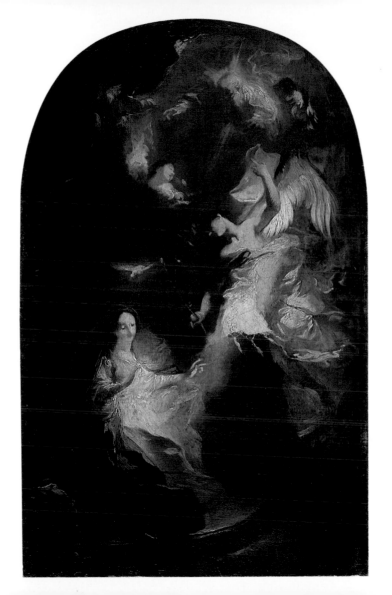

giovanni battista pittoni

oil on canvas

1758

accademia, venice

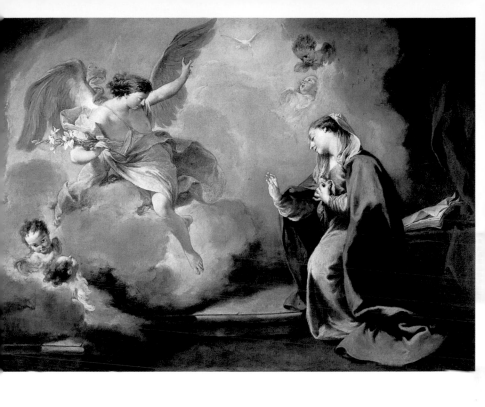

this interpretation was so badly received
when it was exhibited in 1850 that rossetti
gave up purely religious painting thereafter.
the *atheneum* at the time described it as
'absurd, affected, ill-drawn, insipid,
crotchety and puerile'. it has become,
however, one of the most famous religious
paintings of the nineteenth century.

dante gabriel rossetti
oil on canvas
1850
tate gallery, london

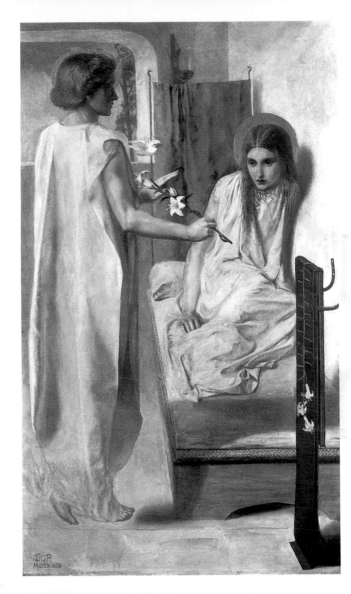

eugène amaury-duval

oil on canvas

1860

musée d'orsay, paris

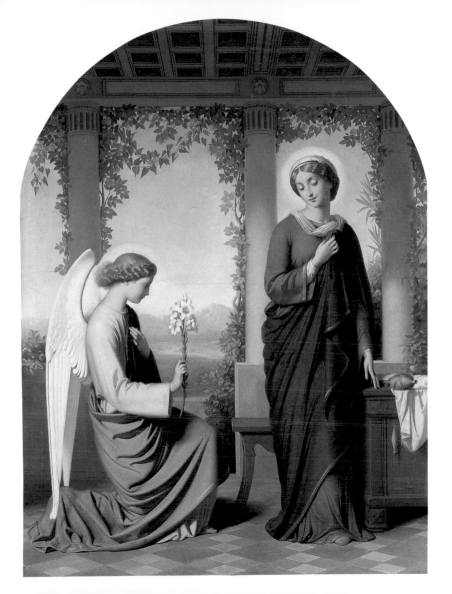

julia margaret cameron

albumen print

c.1868

royal photographic society, bath

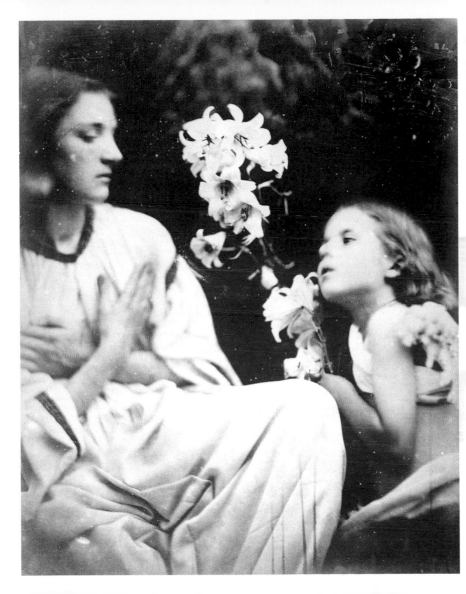

william adolphe bouguereau

oil on canvas

c.1879

private collection

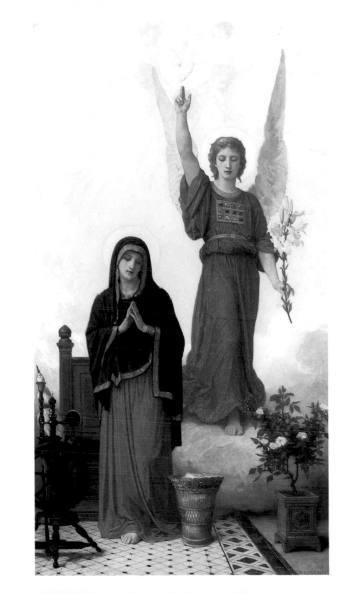

edward burne-jones

oil on canvas

1879

lady lever art gallery, liverpool

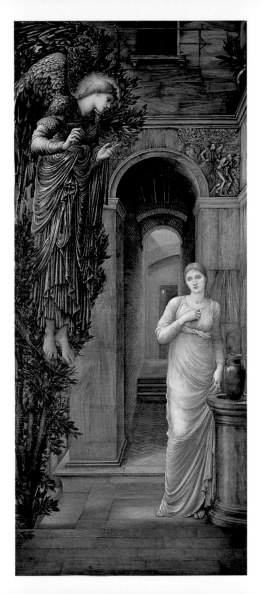

212

maurice denis

oil on canvas

1891

private collection

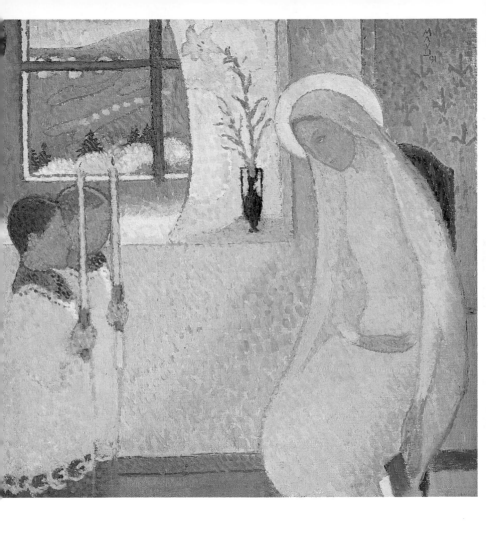

james tissot

oil on canvas

c.1894–5

brooklyn museum of art

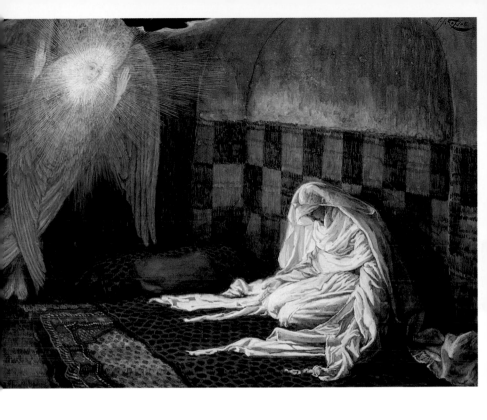

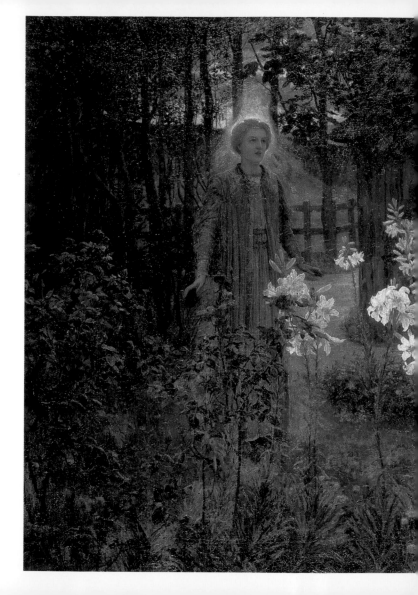

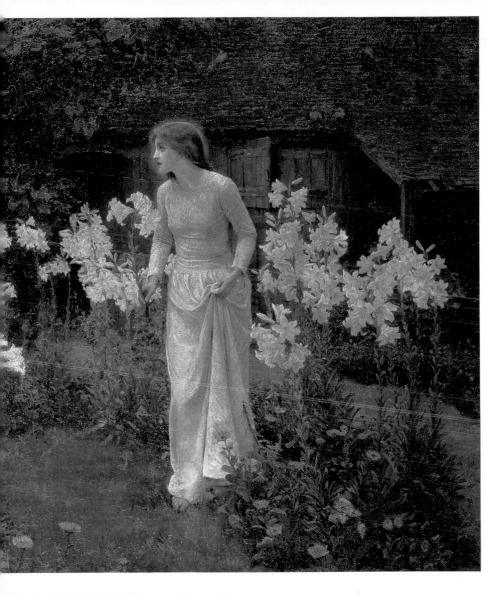

(previous pages)
beatrice parsons
oil on canvas
1897–9
private collection

henry ossawa tanner
oil on canvas
1898
philadelphia museum of art

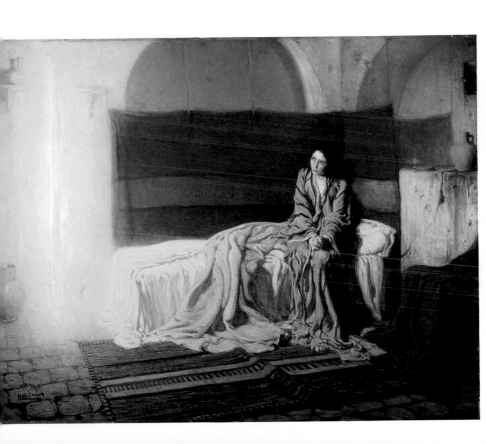

in this, one of the few entirely original
annunciations of the twentieth century,
kokoschka alludes to a theme popular in
early byzantine art, where the virgin is
surprised by the arrival of gabriel (here,
unusually, naked) while collecting water
at a well. her water-jar, cast aside in
surprise, can be seen in the lower
right-hand corner.

oskar kokoschka
oil on canvas
1911
museum am ostwall, dortmund

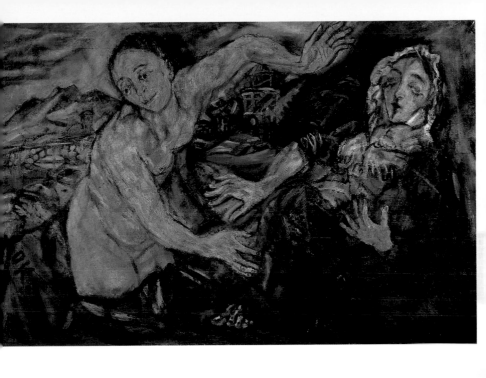

edward reginald frampton

oil on canvas

c.1912

private collection

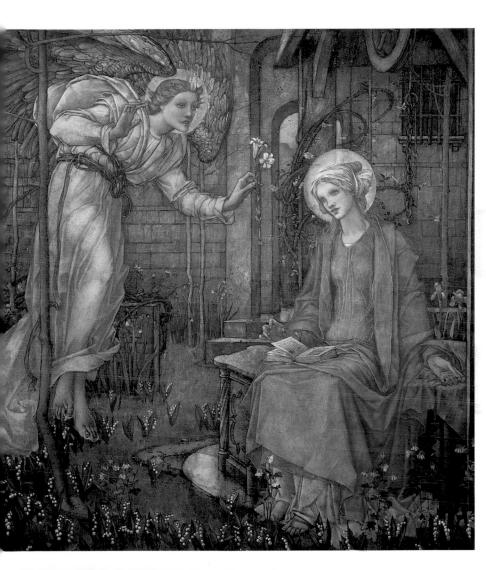

maurice denis

oil on canvas

1913

musée d'art moderne de la ville de paris

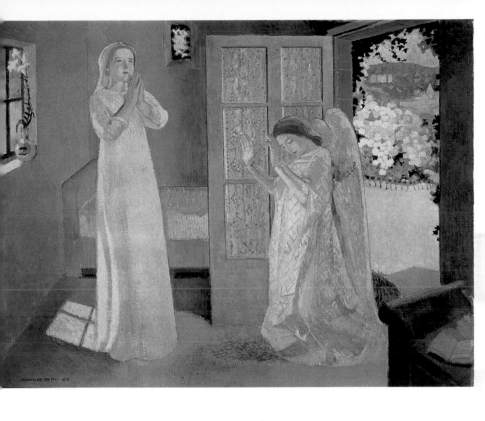

john william waterhouse

oil on canvas

1914

private collection

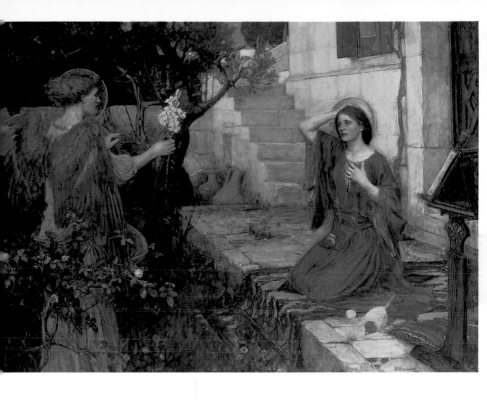

228

rené magritte
oil on canvas
1930
tate gallery, london

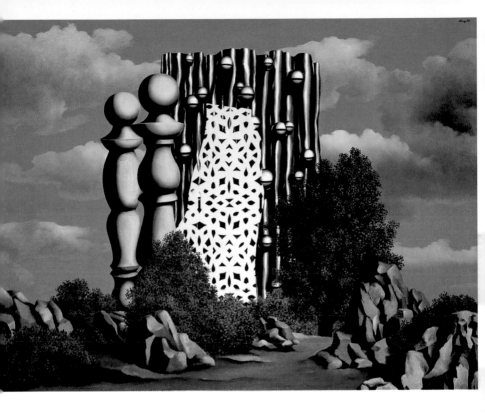

giacomo manzù

bronze relief

1931

private collection

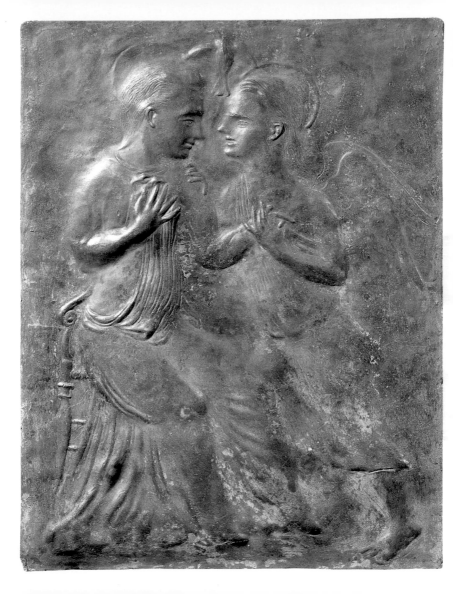

paul delvaux

oil on wood

1949

southampton art gallery

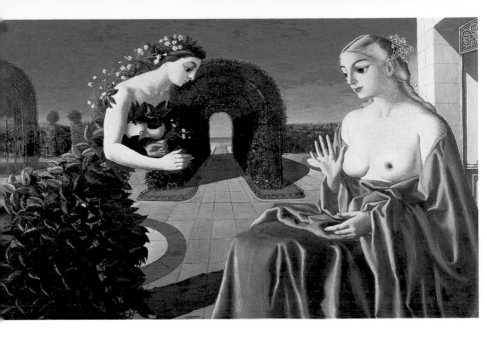

salvador dalí
oil on canvas
1960
collezione d'arte religiosa moderna,
vatican, rome

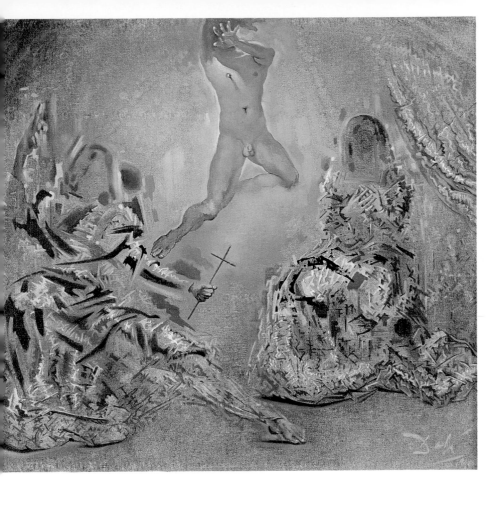

gerhard richter
oil on canvas
1973
private collection

brice marden

oil and wax on canvas

1978

private collection

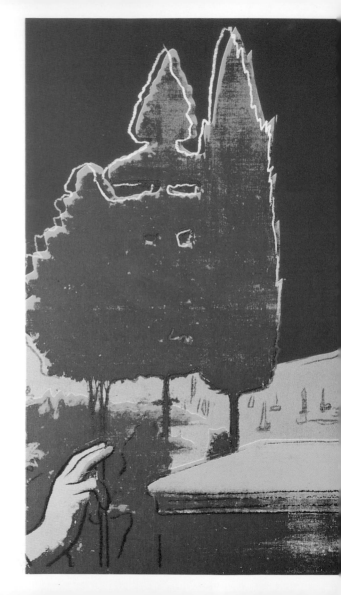

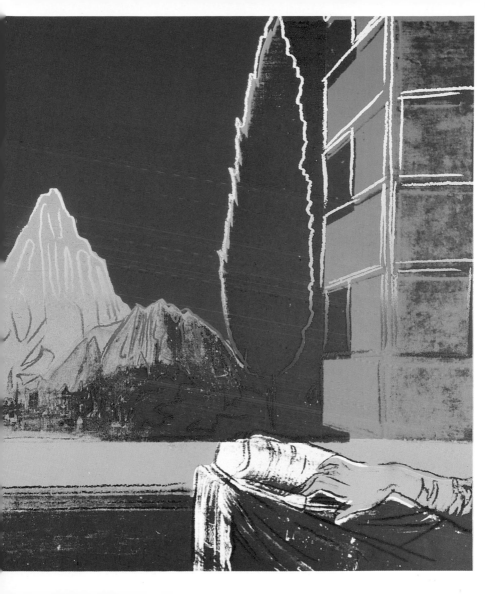

(previous pages)
andy warhol
silkscreen ink and acrylic on canvas
1984
andy warhol museum, pittsburgh

komar and melamid
steel, water, oil and gold leaf
1990
holy rosary church, jersey city

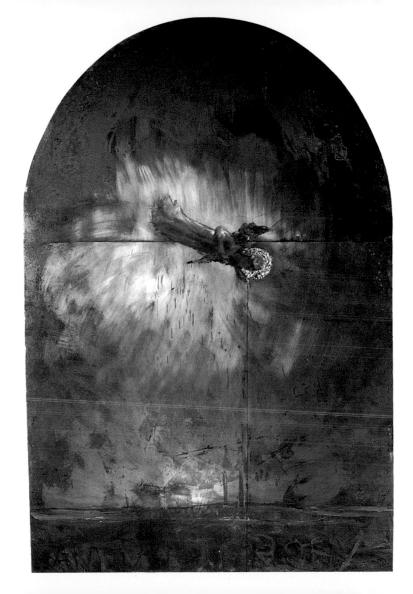

dimensions and additional information

all works are entitled *the annunciation* unless otherwise stated below. where no artist's name has been specified in the main caption, the work is anonymous.

p. 5 santa maria maggiore, rome, italy
p. 7 detail of a silk panel
diameter 33.6 cm, 13⅛ in.
biblioteca vaticana, rome, italy
p. 9 19.8 x 9.4 cm, 7¾ x 3¾ in.
castello sforzesco, milan, italy
p. 11 from the codex egberti
ms. 24, f. 9r
staatsbibliothek, trier, germany
p. 13 16.5 x 11.8 cm, 6½ x 4⅝ in.
staatliche museen, berlin, germany
p. 15 18.4 x 11.9 cm, 7¼ x 4⅝in.
staatliche museen, berlin, germany
p. 17 gallery of icons, ohrid, macedonia
p. 19 from the homilies of james of kokkinobaphos
biblioteca vaticana, rome, italy
p. 21 the ustyug annunciation
25.8 x 16.8 cm, 9⅝ x 6⅝ in.
tret'yakov gallery, moscow, russia
p. 23 from a swabian gospel manuscript
württembergische landesbibliothek, stuttgart, germany
p. 25 chartres cathedral, france

p. 27 from the klosterneuburg altarpiece
klosterneuburg abbey, austria
p. 29 reims cathedral, france
p. 31 santa maria in trastevere, rome, italy
pp. 32–3 scrovegni chapel, padua, italy
p. 35 from the 'maestà' altarpiece
44 x 43 cm, 17⅜ x 17 in.
national gallery, london, uk
p. 37 from the hours of jeanne d'evreux
acc. 54.1.2, f. 16r
cloisters collection, metropolitan museum of art, new york, ny, usa
pp. 38–9 44 x 71 cm, 17¼ x 28 in.
louvre, paris, france
p. 41 184 x 210 cm, 72½ x 82¾ in.
uffizi, florence, italy
p. 43 167 x 125 cm, 65¾ x 49½ in.
musée des beaux-arts, dijon, france
p. 45 from the 'très riches heures du duc de berry'
musée condé, chantilly, france
p. 47 41 x 49 cm, 16⅛ x 19¼ in.
pinacoteca vaticana, rome, italy
p. 49 central panel of a triptych
64.1 x 63.2 cm, 25¼ x 24⅞ in.
cloisters collection, metropolitan museum of art, new york, ny, usa
p. 51 77.5 x 64.4 cm, 30½ x 25⅜ in.
metropolitan museum of art, new york, ny, usa

p. 107 88 x 71 cm, 34⅞ x 28 in.
uffizi, florence, italy

p. 109 207 x 146.7 cm, 81½ x 57¾ in.
national gallery, london, uk

p. 111 musée de cluny, paris, france

p. 113 150 x 156 cm, 59 x 61⅜ in.
uffizi, florence, italy

p. 115 42 x 26 x 4 cm, 16½ x 10¼ x 1½ in.
musée de cluny, paris, france

p. 117 158 x 107 cm, 62¼ x 42⅛ in.
louvre, paris, france

p. 118 29.5 x 21 cm, 11⅝ x 8¼ in.

p. 119 12.7 x 9.7 cm, 5 x 3⅞ in.

p. 121 76 x 79.4 cm, 29⅞ x 31¼ in.
louvre, paris, france

p. 123 40 x 32 cm, 15¾ x 12⅝ in.
städelsches kunstinstitut, frankfurt am
main, germany

p. 125 88 x 86 cm, 34⅝ x 33⅞ in.
gemäldegalerie, berlin, germany

p. 127 wing from the isenheim altarpiece
269 x 142 cm, 105⅞ x 55⅞ in.
musée d'unterlinden, colmar, france

p. 129 *the angel's greeting*
height of figures 218 cm, 85⅞ in.
st lorenz, nuremberg, germany

pp. 130–1 185 x 362 cm, 72⅞ x 142½ in.
santuario della santa casa, loreto, italy

p. 133 from the hours of bona sforza
add. ms. 34294, f. 41r

british library, london, uk

p. 135 6 m x 5 m, 19 ft 8 in x 16 ft 5 in.
palais du tau, reims, france

p. 137 42.2 x 29.2 cm, 16⅝ x 11½ in.
alte pinakothek, munich, germany

pp. 138–9 santa felicità, florence, italy

pp. 140–1 96 x 189 cm, 37¾ x 74⅜ in.
palazzo pitti, florence, italy

p. 143 166 x 114 cm, 65⅜ x 44⅞ in.
museo civico, recanati, italy

p. 145 208 x 144 cm, 81⅞ x 56⅝ in.
pinacoteca ambrosiana, milan, italy

p. 147 166.4 x 266.7 cm, 65½ x 105 in.
scuola grande di san rocco, venice, italy

pp. 148–9 102 x 196 cm, 40⅛ x 29⅞ in.
musée des beaux-arts, caen, france

p. 151 237 x 222 cm, 93¼ x 87⅜ in.
san martino, sarteano, italy

p. 153 40.5 x 54.5 cm, 16 x 21½ in.
uffizi, florence, italy

pp. 154–5 143 x 291 cm, 56¼ x 114⅝ in.
uffizi, florence, italy

p. 157 239 x 171 cm, 94 x 67¼ in.
palazzo ducale, urbino, italy

p. 159 4.2 m x 5.5 m, 13 ft 10 in. x
18 ft 2 in.
scuola grande di san rocco, venice, italy

p. 161 315 x 174 cm, 124 x 68½ in.
prado, madrid, spain

p. 163 224 x 200 cm, 88⅛ x 78¾ in.

museum am ostwall, dortmund, germany

p. 223 private collection

p. 225 musée d'art moderne de la ville
de paris, france

p. 227 99 x 135 cm, 39 x 53 in.
private collection

p. 229 114 x 146 cm, 44⅞ x 57½ in.
tate gallery, london, uk

p. 231 private collection

p. 233 99.7 x 159.7 cm, 39¼ x 62⅞ in.
southampton art gallery, uk

p. 235 *the trinity for the ecumenical council*
collezione d'arte religiosa moderna,
vatican, rome, italy

p. 237 150 x 250 cm, 59 x 98½ in.
private collection

p. 239 *conturbatio*
213.4 x 243.8 cm, 84 x 96 in.
private collection

pp. 240–1 *details of renaissance paintings
(leonardo da vinci 'the annunciation' 1472)*
121.9 x 182.9 cm, 48 x 72 in.
andy warhol museum, pittsburgh, pa, usa

p. 243 *c.*274 x 122 cm, 108 x 48 in.
holy rosary church, jersey city, nj, usa

picture acknowledgements

akg london: 85, 147, photo erich lessing: 27, 129; art resource, new york/© the andy warhol foundation for the visual arts, inc./ars, ny and dacs, london 2000: 240–1; artothek, peissenberg: 101, 123, 137; biblioteca–pinacoteca ambrosiana, milan: 145; brice marden at plane image, new york/© ars, ny and dacs, london 2000: 239; bridgeman art library, london: 69, 169, 175, 185, 189, 223; bridgeman art library, london/ © adagp, paris and dacs, london 2000: 225; bridgeman/giraudon: 135, 148–9; bridgeman/maas gallery, london: 216–17; bridgeman/maas gallery, london/© dacs 2000: 233; british library, london: (add. 34294, f. 41) 133; brooklyn museum of art, new york: 215; © adagp, paris and dacs, london 2000: 213; diözesanmuseum, cologne: 67; fitzwilliam museum, university of cambridge: 72–3; photographie giraudon, paris: 25, 29, 43, 45, 71, 87, 91; index, florence: 83, 153, photo summerfield: 154–5, photo vasari: 5; institut amattler d'art hispanic, barcelona: 64–5; kunstammlung zu weimar, schlossmuseum: 179; kunsthistorisches museum, vienna: 163; metropolitan museum of art, new york: cloisters collection (1954): 37, cloisters collection (1956): 49, friedsam collection, bequest of michael friedsam (1931): 51, gift of j pierpont morgan (1917): 55, gift of mr and mrs charles wrightsman (1973): 191; minneapolis institute of arts, ethel morrison van derlip fund: 197; musée de grenoble: 177; musée d'unterlinden, colmar, photo octave zimmermann: 92–3; museum am ostwall, dortmund, photo jürgen spiler/© dacs 2000: 221; national gallery, london: 35, 89, 109, 187; national gallery of art, washington dc: andrew w mellon collection: 53, 59, samuel h kress collection: 77; board of trustees of the national museums and galleries on merseyside (lady lever art gallery): 211; museo nacional del prado, madrid: 75, 161; philadephia museum of art: w p wilstach collection, photo graydon: 219; studio gerhard richter, cologne: 237; rmn, paris: 165, 205, photo arnaudet: 193, photo bulloz: 81, photo gérard blot: 111, 115, 117, 121, photo blot/jean: 199, photo jean: 63, photo r j ojeda: 173, photo jean schormans: 38–9; ronald feldman fine arts, new york, photo d james dee: 243; royal photographic society, bath: 207; scala group, antella, florence: 7, 9, 17, 21, 31, 32–3, 47, 57, 61, 95, 96–7, 98–9, 102–3, 105, 107, 113, 130–1, 138–9,

phaidon press limited
regent's wharf
all saints street
london n1 9pa

phaidon press inc
180 varick street
new york, ny 10014

www.phaidon.com

first published 2000
reprinted in paperback 2004, 2005, 2006, 2008, 2010
© 2000 phaidon press limited

isbn 978 0 7148 4447 3

a cip record for this publication is available from the british library.

designed by julia hastings
printed in china

the scripture quotation on page 3 of this publication is taken from the new revised
standard version of the bible © 1962, 1973, 1977 oxford university press.